D0618790

Copyright © 1992 by the Bowers Museum of Cultural Art. All rights reserved. This book may not be reproduced in whole or in part by any means, whether mechanical or electronic, without the written permission of the Bowers Museum of Cultural Art, 2002 North Main Street, Santa Ana, California 92706, except for brief passages used in a review.

ISBN 0-9633959-1-2

Publisher
Cultural Arts Press
The Bowers Museum of Cultural Art

Edited by
Armand J. Labbé

Photography
Object Photos: Rudolf, Bogotá, D.E. Colombia
Site Photos: Peter Keller (page 21) and Armand J. Labbé (pages 13, 14 and 23)
Object Photos are reproduced with the permission of "El BANCO DE LA REPUBLICA – MUSEO DEL ORO, Santafé de Bogotá, D.C., Colombia."

Designed by
Barbara Smiley
Smiley Graphics

Printing by
Pacific Rim International Printing

Manuscript Typing and Formatting
María Teresa Inga

Editorial Staff
Jacqueline Bryant
Aleida Rodríguez

English Translations from Spanish
Introduction: Armand J. Labbé and María Teresa Inga
Essay: Hanka de Rhodes

Special thanks are due to Avianca Airlines for their generous support of this project.

CONTENTS

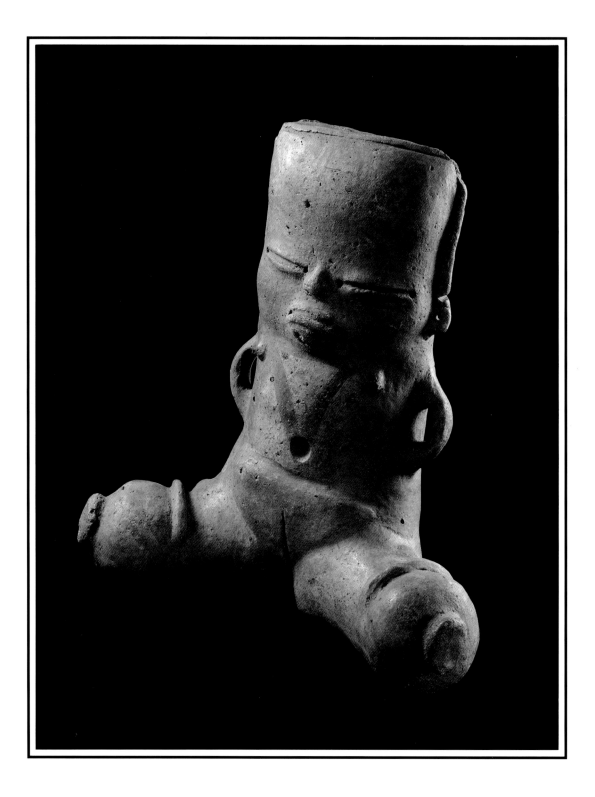

Seated Female, Ranchería Culture, Northern Colombia.

FOREWORD

As the Bowers Museum of Cultural Art opens its doors to the public, it emerges as a vital new museum with greatly enlarged and improved facilities, yet it remains a museum with rich traditions and collections. One of the strongest areas at the Bowers Museum is its collection of Pre-Columbian art and artifacts. Largely through the efforts of our Director of Research and Collections, Armand Labbé, our Pre-Columbian collections have grown as has our academic stature.

While our Pre-Columbian collections represent most of the Mesoamerican and South American cultures, our particular interest has been focused on Colombia. Mr. Labbé's book *Colombia Before Columbus* is just one indication of this interest. I have also personally taken a keen interest in Colombia over the past twenty years, largely as it relates to emeralds, but also in the curation of two major gold exhibits: *Sweat of the Sun, Tears of the Moon: Gold and Emerald Treasures of Colombia*; and in 1985, *Gold: The Quest for New World Treasures*. Both exhibits were solely through the auspices of the *Museo del Oro*.

In October of 1991, Armand Labbé and I went to Colombia with Pat House and the Fellows of the Bowers Museum to meet with Clemencia Plazas and her staff at the *Museo del Oro* and discuss the possibility of another major gold exhibit in the United States. The reception and response was superb; the exhibition has subsequently been entitled *Tribute to the Gods: Masterpieces of the Museo del Oro*. It consists of three hundred forty superb objects, largely gold, but with some major ceramic pieces as well. This publication depicts only about forty of the displayed objects, but these forty are an excellent representation of the exhibit. We are very pleased with the opportunity to work in partnership with the *Museo del Oro*.

Another Colombian partner that has always been a strong supporter and has continued its support for *Tribute to the Gods*, is Avianca Airlines. Avianca is a major sponsor of this exhibit, and for this the Bowers Museum is extremely grateful. The exhibit could not have happened without this support.

Tribute to the Gods promises to be one of the largest exhibitions of Pre-Columbian gold from the *Museo del Oro* ever seen in the United States. It is fitting that it is also one of the premiere inaugural exhibits as the new expanded Bowers Museum of Cultural Art celebrates its grand re-opening.

Peter C. Keller, Ph.D.
Executive Director
The Bowers Museum of Cultural Art

PREFACE

Colombia is an ancient land of powerful and moving, contrasting beauty. Snowclad peaks of the Sierra Nevada de Santa Marta peer through clouds upon the deep, warm, sapphire-blue waters of the Caribbean.

Along its slopes, hidden from the bustle of the city at its foothills, are the scattered enclaves of the Kogi, an ancient native people. To the southeast, along the verdant slopes and highlands of the Eastern Cordillera, cultures flourished and perished with the seasons of time. The mightiest of these, the ancient Muiscas, were the lords and caretakers of the beautiful highland savannas, and sacred lagoons, where a sprawling metropolis now dominates the land.

The muddy, dreamy Magdalena River winds its course between the Eastern and the Central Cordilleras in a manner reminiscent of its sister river, the Cauca to the west. Both are born far to the south in mountain massifs of tremendous power, beauty, and sublimity. Here another ancient race left its mark in the form of sculptured stone to be found on mountain tops, cliffs, forested haunts, or as guardians of cryptic graves, in regions now called San Agustín and Tierradentro.

Still further to the south lie the breath-taking, dizzying heights of the mountains of the Department of Nariño, where the power of the Inca was thwarted by native resolve. To the east and northeast lie the jungles of the Amazon, while far to the west lie the mangrove swamps of the coastal regions.

The Cauca River cushioned between the slopes of the Central and Western Cordillera follows its course northward across the length of the country winding through the Cauca Valley until finally it continues its course through a vast region of grassy lowlands, comprising a broad flood plain coursed by the meanders of numerous rivers, such as the Río San Jorge, the Río Nechi, and the Río Sinú.

This land, Colombia, of unparalleled beauty was home to numerous ancient civilizations some of whom, with respect to thought and culture, must be ranked among the most sophisticated of the Americas. In many parts of the land the faces of the past can still be seen in the countenances of their descendants, who increasingly strive to have their voices heard and their perspectives given due consideration.

In an age when values and customs are shaped by economics more than any other factor, it is often difficult to step outside the bounds of culture to listen to the wisdom of another age. The wisdom of the ancient Muiscas and Taironas valued nature over profit. The native peoples saw themselves as caretakers and guardians of the land. The surviving beauty of the land and the commentary inherent in their ruined cities is ample evidence of the efficacy of their wisdom and stewardship.

The world of the Pre-Columbian Indian was an integrated world. It was a world fashioned by perceived relationships between the earth, the sky, and waters; between the earth, sun, moon, and stars; between the earth, plants, animals, and human beings.

Life followed certain established laws determined by the sacred order of nature. All living things emerged, grew, waned, and died in the same manner as the unfolding of the seasons. All living things were inextricably bound in a web of interdependencies. Human life, therefore, followed closely the patterns of nature and the rhythm and flow of the natural order.

In such a world, art was never merely art for arts sake but rather cultural power set in service to the human community. Pre-Columbian art is overwhelmingly iconographic and symbolic, keyed to indigenous mythology, science, and philosophy. This is particularly true of the indigenous artworks in gold, a metal valued not so much for its commercial merits but because of its value to rite, ritual, dance, and as an offering of great merit.

The value of gold to the indigenous peoples was linked to the properties ascribed to it by the native shamans and priests. The Kogi Indians of the Sierra Nevada de Santa Marta associate gold with the fertilizing energy of the sun. Even today, gold artifacts, heirlooms of the past, are exposed to the sun at certain times of the year at special sacred localities in the belief that the gold thereby acquires new fertilizing energies. The sun is said to fertilize the gold and thus empower it. (Reichel-Dolmatoff, G., 1988).

The Bowers Museum of Cultural Art is therefore privileged to join the world-renowned *Museo del Oro* in affording our patrons the opportunity of experiencing the sacred gold artworks of Pre-Columbian Colombia and viewing a *Tribute To The Gods*.

Armand J. Labbé
Director of Research and Collections
The Bowers Museum of Cultural Art

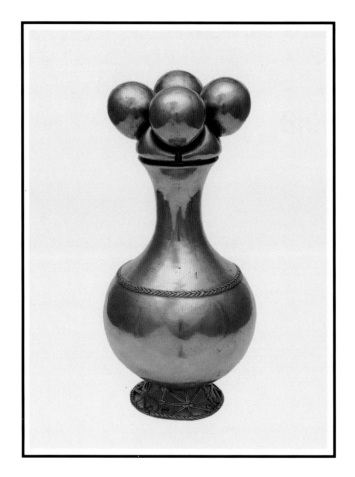

Lime Flask, Classic Quimbaya Style.

INTRODUCTION

The Museo del Oro and National Awareness in Colombia

The establishment of the *Museo del Oro* by the *Banco de la República* half a century ago coincided with a renewed national awareness, a need to salvage surviving cultural values from the past, and a desire to more deeply understand the indigenous societies spread across the length and width of our land.

By the late 1930s a few gold artifacts made their way to the central office of the *Banco de la República* in Bogotá from one of the regional gold purchasing agencies of the bank, which is the institution in Colombia that has controlled the trade in gold since its establishment in 1913.

Soon, eleven additional pieces were purchased from a private party. In March of 1939, then Bank Manager Mr. Julio Caro presented the following proposal from Dr. Alfonso Arango, Minister of Education:

> "earnestly recommends that the Bank embark on a mission to preserve the gold and silver artworks of Pre-Columbian manufacture, which the Ministry of Education would purchase for the value of its gold or silver content and further wishes to present for consideration of purchase a perfectly formed gold vessel that Mrs. Magdalena de Maldonado presently offers for sale" (Banco de La República: 1939).

In 1939, the Federal government also created the National Archaeological Service under the supervision of the Ministry of Education. In 1941, with the invaluable assistance of French anthropologist Paul Rivet, the National Institute of Ethnology was established. These developments laid the foundation for the scientific investigation of our Pre-Columbian heritage. Both institutions were formally integrated in 1945 to form the present Colombian Institute of Anthropology entrusted with the care and preservation of Colombia's archaeological patrimony. The *Museo del Oro* has had a close working relationship with the institute since its establishment.

The Destruction of the Indigenous Cultures

The Spanish Conquest and the ensuing pursuit of gold and riches had all but totally destroyed the indigenous cultures of Colombia. With the passing of four generations, both the conquest and the destruction of the native lifeways were but fading memories.

The contrast in ideology between the Old World and the New was striking. The conquistadors wanted gold for its monetary value, while for some indigenous peoples it was simply another material like clay, until it was transformed by the goldsmith (Helms, Mary: 1979).

For many native American cultures, gold represented the concretized, materialized creative essence of the sun. Man, through his rituals, participates in the act of creation. Gold played a key role in these rites and rituals. Because of its association with the creative force of the sun, gold was worn during battle, was buried with the dead, and was used as an offering at the shrines and lagoons.

The Age of Awareness

The nineteenth century ushered in a new era, which can be described as a desire to rediscover the wonders and realities of Colombia (Londoño Velez, Santiago: 1990). There was renewed interest in geography and in the natural fauna and flora. Men such as José Celestino (1783-1810) not only led important botanical expeditions but also described some of the ruins and vestiges of the Pre-Columbian civilizations.

In 1816, Humboldt published in France his work titled Vue des *Cordilleres, Et Monumens Des Peuples Indigenes de L'Amerique* in which he discusses the sacred Lake Guatavita and in which he illustrated gold art offerings and Pre-Columbian ceramic vessels from the central highlands. This book inspired interest in Europeans such as J.B. Boussingault (1822), William Bollaert (1860), Charles Saffray (1869), and Eduard André (1877), who left us written records of their personal observations on the Pre-Columbian legacy of Colombia.

Following independence from Spain in 1810, which was led by the *criollos* (Spaniards born in the Americas) who wished to have the same rights as those afforded to the Spanish (those born in Spain, but residing in Colombia), it became increasingly clear that a national identity, distinct from that of Spain, needed to be forged.

In 1824 the National Museum was formed and many important scientific studies and expeditions were undertaken. One of these, commissioned by the *Comisión Corográfica* (1850-1859) and led by Augustín Codazzi "integrated the country into the modern era and made [Colombians] understand both the incumbent responsibilities and good fortunes of sovereignty as a legal, human, historical and geographical reality." (Barney Cabrera, Eugenio: 1977)

The published reports of this expedition included illustrations and descriptions of archaeological sites, stone sculptures, ceramics and gold artifacts, as well as the first map of the archaeological sites of the San Agustín region.

By the mid nineteenth century, Ezequiel Uricoechea published his book *Antigüedades Neogranadinas* in Berlin, which focused on a study of the Chibchas and Quimbayas

(Uricoechea, Ezequiel: 1854). This work by a distinguished philosopher is widely considered the pioneer work for the study of Colombian Archaeology. It describes in great detail each archaeological artifact and the complex technology that went into its manufacture, with the express purpose of opposing the theory engendered by the Spanish chroniclers that the native populations were primitive and barbaric.

With the discovery of rich tombs in the Department of Quindio along the Cauca River Valley by as early as 1840, the looting of graves once again intensified.

> "It was very common to find entire families dedicated to this work. These families used to live a nomadic life, carrying with them the proper tools, groceries, and other requisites. They camped in areas previously chosen for excavation.....they lived out their fantasies and illusions, some of which turned into realities, but others only fomented the voices of protest and bitterness. Days, weeks, and even months would go by without a single find to compensate them for their many sleepless nights and obsessions."
> (Forero, Çantos: 1966)

Small settlements were established in the archaeological regions of the Calima and Quimbaya cultures by farmers who even to this day apply themselves to the systematic looting of the indigenous tombs.

The tombs, typically shaft graves with lateral chambers in which were placed the grave offerings, were located at the center of the indigenous villages. The *guaqueros* (grave robbers) in their search for buried treasure, destroyed much of the data and evidence that is so useful in archaeological investigations.

The looters, interested mainly in treasure, left many of the ceramic artifacts in the tombs, while many others were broken in pursuit of gold. The gold artworks more often than not were destined to be melted down in the smelting pots of Medellín. A few artworks were saved by collectors such as Leocadio María Arango and Vicente Restrepo. Some of these were later acquired by the *Museo del Oro* (Londoño Valdez, Santiago: 1990).

Vicente Restrepo studied chemistry and geology in Europe. Upon his return to Colombia, he established a gold metallurgical laboratory in Medellín. His interest in mining and metallurgy led him to study and collect Pre-Columbian artifacts. His interests were pursued by his son Ernesto, who wrote Ensayo Etnográfico y Arqueológico de la Provincia de los Quimbayas (An Ethnographical and Archaeological Essay on the Province of the Quimbayas), which was published in 1892 and re-edited in 1912 and 1929. Vicente and Ernesto were responsible for assembling the Colombian display that was exhibited in 1892 at the American Historical Exposition in Spain, commemorating the four-hundred-year anniversary of the discovery of the Americas. The Colombian display had twelve hundred objects. The most outstanding of these was a group of one hundred artworks of superior beauty and manufacture called the "Treasure of the Quimbayas." These artworks had been discovered only one year before with six burials found in two tombs in the Municipality of Finland, Department of Quindio. It was purchased by the Colombian government, under the administration of Carlos Holguín, for $10

to be presented as a gift to the Spanish Crown, María Cristina of Hapsburg (Plazas, Clemencia: 1978). President Holguín ten years earlier had been Colombian Ambassador to Spain at a time when diplomatic relations between the two countries had been reestablished for the first time since 1810.

The size, weight, beauty, and sophistication of these artworks awed the Europeans. Although this gift was a loss of Colombian national patrimony, it drew attention to the height and sophistication of the Pre-Columbian Colombian artists, for these works were ranked by the critics among the finest in the world. One Spanish magazine exclaimed the gift as "the best present from our daughters throughout the Atlantic Sea" (La Ilustración Española y Americana: 1892), while famed Americanist Eduard Seler wrote in 1915 with regards to these artworks: "With regards to the gold work, no other collection in the world is comparable with the one exhibited in the Colombian section of the historical exposition of Madrid in 1982." (Pérez de Barradas, José: 1966)

Of the eight ceramic objects that were on exhibit, the majority were purchased by the Field Museum of Chicago. The Treasure of the Quimbayas is kept at the American Museum of Madrid. The rest of the artworks in the exhibit were dispersed to several museums in Europe and none were ever returned to Colombia.

The Fourth Centennial, like the present Quincentenary of the Discovery of the Americas, focused attention on this continent. During the last two decades of the nineteenth century, several significant studies were published, such as those authored by Carlos Cuervo Márquez and Vicente Restrepo, pioneer forerunners of Colombian archaeology developed later in the twentieth century.

European interest in exotic antiquities reached its peak at the end of the nineteenth century. In addition to ransacking Greek, Babylonian, and Egyptian art, dozens of Colombian archaeological antiquities were purchased at the time for private and national museums by diplomats on tour of duty in Colombia. This was the manner in which the huge collections of the British Museum, the Dahlem Museum in Berlin, and the Ubersee Museum of Bremen, among others, were formed (Plazas, Clemencia: 1972-73).

There were also many non-Colombians who undertook studies on Colombian prehistory. In 1883 the Marquess de Nadillac published *L'Amerique Prehistorique* in Paris, which was followed in 1885 by an article on the ancient inhabitants of Colombia. In this same year, Bryce-Wright wrote a description of the Colombian goldworks from the Lady Brassey Collection now at the Birmingham Museum. In 1886 E.T. Hamy published his *Etudes Ethnographiques et Archaeologiques sur l'Exposition Coloniales et Indienne de Londres*. The following year, George Kuntz published the essay "Gold Ornaments from U.S. of Colombia," and in 1897 C.H. Read published an essay on Colombian prehispanic goldwork in the journal of the Anthropological Institute of Great Britain.

During the first decades of the twentieth century, field investigations undertaken by Colombians as well as foreigners were added to the body of work formed by these essays. In 1907 Marshall Seville explored the Tumaco region of Colombia. In 1910 Konrad Th. Preuss investigated the San Agustín region with Carlos C. Márquez, describing the stone sculptures found there.

The book *La Civilización Chibcha* (The Civilization of the Chibchas) was published by Miguel Triana in 1921. That same year, Alden Mason, on an important expedition sponsored by the Field Museum of Chicago, explored the vestiges of the Tairona Culture of the Sierra Nevada de Santa Marta. Mason's work resulted in three important studies published in 1931, 1936, and 1939.

Between 1914 and 1919 an important series of articles were published by the Frenchman Paul Rivet, in association with Arsandaux and Créqui Monfort in the journal of the Americanist Society in Paris. Published under the title *Contribution de l'etude de l'archaeologie et de la metallurgie colombienne*, this constituted the first comprehensive study of prehispanic Colombian goldwork.

In 1926, Rivet and Marcel Mauss created the Ethnological Institute in Paris. In 1941, following the Nazi invasion of France, Rivet fled to Colombia with the assistance of then-president Eduardo Santos. For two years, he served as counsel and professor for the first group of professional archaeologists of Colombia (Londoño Vélez, Santiago: 1990).

The Museo del Oro and Fifty Years of Studying, Documenting, and Reconstructing Prehistory

The *Museo del Oro* was laid on a solid foundation of national interest in its prehispanic past. In 1944, with four thousand prehispanic goldworks acquired mainly from private collections, the museum opened its doors to select visitors. During this same year, the first catalogue was published. Two years later, in 1946, the first ceramic artwork was purchased. The first room specifically built to hold the collection was located on the third floor of the building named after Pedro A. López, where the *Banco de la República* offices were located.

With the construction of a new building for the *Banco de la República*, a special room was designed for the museum in the basement of the building. This facility accommodated the increasing number of visitors to the museum during regular business hours.

Numerous museum administrations have contributed to the evolution of the *Museo del Oro*. The museum was under the direction of Luis Barriga del Diestro from 1939 to 1976, under Luis Duque Gómez from 1977 to 1986, María Elvira Bonilla from 1983 to 1986, and under my direction since 1987.

During the 1960s, the artistic merits of the collection and the national and international prestige and popularity of the museum led to the planning and designing of a new permanent facility that would not only house the collections and exhibit galleries but would also provide offices and areas for study and research. This official opening of the new facility at the present location of the *Museo del Oro* took place on April 22, 1968.

The present facility has three main exhibit areas with 1,250 square meters of floor space arranged in such a manner that the visiting public is guided through from the more general displays to the more specific, revealing the rich cultural context from which the gold derives.

Since its opening, the museum has organized exhibits of national and international significance in the main exhibition hall, on the first floor of the present facility. The first

exhibition, titled *The Legend of El Dorado*, opened in 1968. Many more were to follow: *El Oro de América* (America's Gold), *El Tráfico de Oro con España* (The Gold Trade with Spain), *Mil Años de Historia Tairona* (A Thousand Years of Tairona History), and *Oro Clásico Quimbaya, Una Aproximación* (An Approach to Classic Quimbaya Goldwork).

In 1977, the first non-Colombian international exhibition, titled *Oro y Textiles del Perú* (Gold and Textiles of Peru), was held in this gallery. It marked the beginning of many fruitful international-exchange exhibitions. Among the most important of these were exhibitions from Chile, México, and Kubán in the southwest of the former USSR.

The second floor of the *Museo del Oro* introduces the visitor to a chronological expose of the different gold-working cultures of Colombia. Charts, illustrations, dioramas, and other graphics place the artworks in relevant cultural contexts. Dioramas are also used to show different burial styles and illustrate the importance of placing gold offerings with the dead to assure continued fertility in the community and a continuity of communication with the deceased.

On the third floor is located a walk-in gold vault. There, one encounters hundreds of works of art in gold representing the eleven most important archaeological zones of Colombia: Tumaco, Calima, Cauca, San Agustín, Tierradentro, Quimbaya, Tairona, Sinú, Tolima, Muisca, and Nariño. As much as possible, attention is focused on the ritual, ceremonial, and sacred meanings attached to the artworks.

The 1980s saw the museum go through a period of decentralization. Since then, a number of important regional museums have been established that specialize in the goldwork of the cultures that were centered there:

> Santa Marta, gold of the Tairona, 1980
> Manizales, gold of the Quimbaya, 1981
> Cartagena, gold of the Sinú, 1982
> Pasto, gold of Nariño, 1985
> Ipiales, gold of Nariño, 1985
> Pereira, gold of the Quimbaya Late Period, 1986
> Leticia, Amazonian Ethnography, 1988
> Cali, Calima gold, 1991

The opening of these new regional museums stimulated a new cultural policy at the national level. Great emphasis is placed in the exhibitions to demonstrate that many of the ancient cultures have survived and are linked to their descendants in the various regions.

To further complement the educational endeavors of the museum, the *Banco de la República* established the *Fundación de Investigaciones Arqueológicas Nacionales* (The Foundation for National Archaeological Investigations) in 1971 for the purpose of supporting and promoting controlled archaeology in Colombia.

This occurred at a critical time, in a decade in which the smuggling and looting of prehispanic artworks was threatening our ability to reconstruct the past. Since its creation,

the foundation, in concert with the Colombian Institute of Anthropology, has sponsored over one hundred fifty projects yielding forty published monographs on Colombian archaeology. These monographs have made a major contribution toward the understanding of the prehistory of Colombia (Banco de La República: 1985).

In order to thwart the illegal export of artworks from Colombia, the museum makes an effort to acquire them from collectors and dealers. To prevent the mass destruction of precious archaeological sites, the museum finances the majority of national archaeological projects.

In the early 1970s numerous important archaeological sites were destroyed by *guaqueros* in the Tairona region. About fifteen thousand gold pieces from this region eventually found their way to the museum. In the same manner, most of the goldwork found by *guaqueros* in the Sinú were acquired by the museum during the same period. With the subsequent discovery of burials from Pupiales, the first Nariño gold artworks were acquired and exhibited to the public.

More recently, the museum has begun to acquire goldwork from the Urabá region in the northwest area of Colombia. These artworks evidence an interesting relationship to works found in southern Central America and with the Sinú and Quimbaya regions of Colombia. As the museum's collections are now representative of all of the major regions of the nation, the museum will only purchase pieces of great research significance or works that will be placed on exhibition.

The *Museo del Oro* has also been actively involved in putting together exhibitions to be shown in other countries. The first international exhibition took place in 1963, as part of the VII Art Biennial of São Paulo, Brazil. Since then, Colombian gold exhibitions from the museum's collections have been seen in eighty seven cities in forty eight countries worldwide, including exhibitions at the Royal Academy in London, the American Museum of Natural History in New York, the Gallery of Fine Arts in Beijing, the Hermitage in St. Petersburg, the Museum Für Volkerkunde in Vienna, the Calouste Gulbenkian Gallery in Lisbon, and the Israel Museum in Jerusalem.

The *Museo del Oro* has become a vital aspect of Colombian life, an institution that has helped to foster pride in its Pre-Columbian heritage and that has sponsored a deep and abiding understanding of this important national legacy and patrimony. By better understanding our past, it is our hope that this will contribute toward the creation of a cohesive society with a solid national identity.

Clemencia Plazas, Ph.D.
Director
Museo del Oro

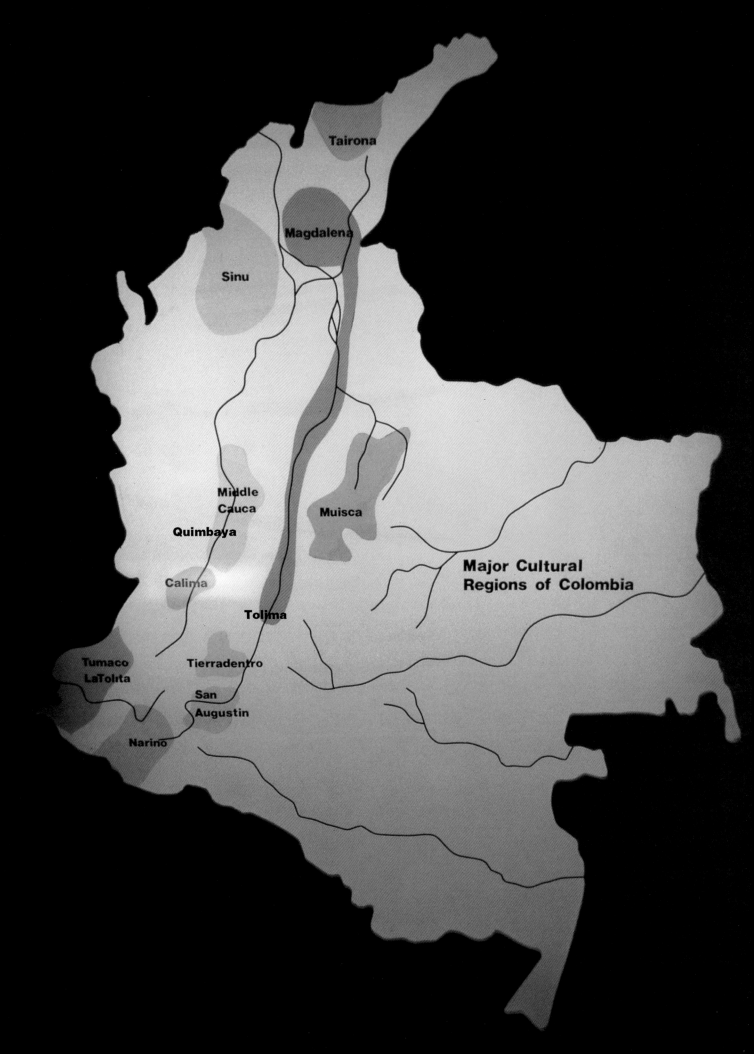

Tairona

Magdalena

Sinu

Middle
Cauca

Quimbaya

Muisca

Calima

**Major Cultural
Regions of Colombia**

Tolima

Tumaco
LaTolita

Tierradentro

San
Augustin

Narino

PREHISPANIC GOLDWORK OF COLOMBIA

T he Pre-Columbian metalwork, created by the different communities scattered throughout the Andes area of Peru to present-day Mexico, was produced during some thirty centuries of continuous development. The principles of metallurgy were known at different times to numerous communities of Central and South America, which adapted them and used them for their own needs and beliefs. Gold-working techniques were already known more than three thousand years ago in the Peruvian highlands (Grossman, Joel: 1972) and, by the year 300 B.C., in the southwest of present-day Colombia (Bouchard, Jean François: 1979). By the beginning of the Christian era, it had spread to a large area of Colombia and northwards to Central America.

The pieces of Colombia's prehispanic goldwork are outstanding for their technical and stylistic variety, which expresses the cultural diversity of the groups that made them. The territory of Colombia, in the northwest corner of South America, was the inevitable route for the immigrants of different origins who inhabited these lands over the centuries, adjusting to their geographic and climatic diversity. Some communities settled in the mountainous Andean areas, where cool-weather plateaus and bleak *páramos* alternate with warm, lush valleys confined by the Cordilleras, while others populated the vast jungles and tropical prairies in the east, on the Pacific coast, and the plains along the Atlantic littoral. Long cultural processes evolved ever more complex societies, which included the metal-working communities.

Between 500 B.C. and the Spanish Conquest, metallurgy flourished among those communities that had a complex socio-political organization, with different social hierarchies and centralized political power. This was conducive to specialization in work areas, so patently manifest in the goldwork.

At different times, metalwork was integrated into major regional developments achieved by groups whose different cultural roots were expressed in their various attitudes towards gold, in their way of working gold, and in the forms they made. Two great metallurgical traditions are readily distinguished in Colombia: that of the southwest, and that of the center and north.

Thus a single cultural tradition extended through the Andean area and the Pacific coast of southwestern Colombia between the years 500 B.C. and 1000 A.D. The archaeological regions known as Tumaco, Calima, San Agustín, Tierradentro, Tolima, Quimbaya, and Nariño were inhabited by communities linked by that tradition and were responsible for the

high level of development associated with spectacular goldwork. However, this prosperity declined after the year 1000 A.D., when different groups populated the region.

From the beginning of the Christian era, the center and north of Colombia were inhabited by groups of different cultural origins, that survived until the time of the Spanish Conquest. These communities developed different styles of working metals but were linked by similar technology. The archaeological area known as Sinú, located in the tropical plains along the Caribbean coast, reached its zenith during the first centuries A.D., with the Zenú culture. The Zenús were skilled and versatile goldworkers who made a variety of adornments that were a symbol of the prestige of their rulers, accompanying them as offerings in their tombs. And while the Zenús settled in the northern lowlands, the mountainous areas of both the north and central region of the country were inhabited by Chibcha-speaking communities that became consolidated as socio-political entities in the last centuries before the Spanish Conquest. The Taironas inhabited the Sierra Nevada de Santa Marta, where a number of urban centers evidence the complexity of this society that produced such spectacular emblematic gold objects, so deeply symbolic. The Muiscas, also Chibcha-speaking, inhabited the high plateau on the Eastern Cordillera, in the present-day departments of Cundinamarca and Boyacá. Their craftsmen produced many gold objects that were deposited as offerings in temples and sanctuaries. These are the last examples of the metalworking traditions that encompass centuries of development, from those remote beginnings of goldwork in Colombia's southwest.

THE GOLD OF THE SOUTHWEST

Tumaco, Calima, San Agustín, Tierradentro, Nariño, Tolima, and Quimbaya

These areas of southwestern Colombia, before the year 1000 A.D. were inhabited by groups that were culturally related and at the same time were capable, over several centuries, of absorbing external influences, allowing the evolution of a particular individuality and character. Their common cultural roots can be observed in various aspects of their organization, which we can assess through the plentiful evidence they have left behind.

These communities had a complex socio-political organization, with delineated social hierarchies and centralized political power. There certainly existed a political and religious elite who used goldwork and sculpture as symbols of privilege. In their tombs they placed these gold objects, many of which have survived to the present day, as proof of their desire for immortality.

These relatively dense groups, judging by their many traces, populated the hillsides and valleys, taking advantage of the different climates. They built drainage channels for the cultivation of a number of crops, the principal one being maize. Houses were built on terraces, clustered together in groups of varying sizes along the hillsides, with easy access to the rivers that provided the necessary water for their households and their fields.

The goldwork left behind by these communities embodies a single metalworking tradition, which shared characteristics of technology, forms, iconography, and function. (Plazas, Clemencia and Ana Maria Falchetti: 1983) In the overall picture of prehispanic goldwork in Colombia, the high degree of purity that distinguishes the pieces from the southwest is due in part to the abundance of gold found in the valleys of the Magdalena and Cauca rivers and of other rivers that flow down towards the Pacific, carrying with

them gold from the Western and Central Cordilleras, forming rich alluvial deposits.

These communities also worked silver and platinum mixed with the alluvial gold. Although silver and platinum are found in other areas of Colombia, it was only in the southwest where they were used in conjunction with gold, due fundamentally to the symbolism of the cultures of the south. These cultures believed gold to be the "Sweat of the Sun," associating it with the life-giving star, the supreme procreator. They believed silver to be related to the moon, the female principle: The moon weeps and her tears are of silver. Mythology explains the symbolism and origin of metals, thus justifying their fundamental role within various cultures.

Technologically, the craftsmanship of the southwest is chiefly concerned with the actual working of the metal, which demands considerable skill and a thorough knowledge of the characteristics of metals. (Plazas, Clemencia and Ana Maria Falchetti: 1983) With small, oval-shaped hammers made of meteoric iron, the goldworkers beat small pieces of gold on a cylindrical stone anvil, until they achieved a sheet of an even thickness. They then outlined their decorative design, placed the sheet on a soft surface, and pressed with metal chisels to emboss the outline.

In order to obtain volume from the gold leaf, the craftsmen joined pieces with gold pins or by making flanges or seams where the pieces were to fit into each other. They also used gold foil to cover objects made of other substances: snail shells, figurines, staffs, and wooden cores which have now disintegrated.

To join together gold sheet, granules, and wires, to form or decorate very intricate items, fusion welding was used. Pieces of fine gold were welded by placing a drop of acetate—obtained by dissolving copper in vinegar—on the spot to be soldered. Heated over a gentle flame in an oxygen-free atmosphere, the organic adhesive burns away and the added copper forms an alloy with the gold, creating a strong, barely discernible union. It is an exacting procedure that requires high temperatures—approximately 25°C below the melting point of the metal (between 800° and 1100°C)—and the slightest error can destroy the entire piece.

These techniques of direct working of the metal predominated among the goldsmiths of southwestern Colombia. However, particularly in the Quimbaya region, metalworkers also perfected the arts of alloying metals. Gold was melted in clay crucibles placed together with charcoal inside a kiln, also made of earthenware. The temperature required to melt the metal was reached by blowing on the charcoal with wicker fans or pottery blowpipes. To make pieces by melting, the lost-wax technique was used. Initially, a model was made with beeswax and was covered with clay; once the mold was heated, the wax melted, leaving a hollow that was subsequently filled with the molten gold. When the mold cooled down, it was broken and the gold article was removed and finished.

These goldsmiths also mixed gold with copper in different proportions to arrive at an alloy known as *tumbaga*. To protect *tumbaga* pieces against the rapid discoloration of the copper, they gilded them by using a method known as gilding by oxidation. The object made from *tumbaga* was heated, the copper then oxidized, producing a surface film of copper oxide, which was subsequently cleaned with an acid solution obtained from plants of the oxalis family. The surface was covered thus with a coating of gold, which became thicker as the process was repeated.

The forms and iconography of the pieces also indicate that gold fulfilled a similar function for

the different southwestern cultures. Predominant are the large, sumptuous ornaments that emphasized the prestige of whoever wore them and served to show a close relationship between nature and man, by representing mythical animals that penetrate the very essence of the existence of man and his powers. Jaguars, serpents, birds of prey, monkeys, and others, all formed a complex symbolic world that has not yet been fully interpreted.

The similarity of the techniques, shapes, iconography, and functions of the gold pieces indicates a common basis that linked the different cultures of the southwest without diminishing their strong regional development. At the same time, nevertheless, these cultures created their own characteristics.

Tumaco

The former inhabitants of Tumaco, on the Pacific coast of Colombia's Southwest, developed an efficient system for exploiting their resources, which combined fishing with intensive cultivation of maize and other crops. This stable mixed economy allowed for cultural advances from the first centuries B.C., which characterized Tumaco and the neighboring region across the Ecuadorian border known as La Tolita, due to the abundance of Tolas, the artificial mounds in which they buried their dead.

Many aspects of the life of these people and their relationship with their environment have reached us through their molded clay figures that show personages variously caparisoned: women, children, old people, erotic scenes, houses, animals, and complex figures where men and animals are combined into a single being.

The earliest gold in Colombia was found in Tumaco: small wires showing sophisticated technology, dating back to the year 325 B.C.

(Bouchard, Jean François: 1979) In high-purity gold sheet, Tumaco goldsmiths embossed large masks with the jaws of jaguars, also pectorals, and human figures with their skulls elongated in the same way as in their clay figures. There is an infinite number of small pieces—nose rings, beads, wires—that undoubtedly served to embellish human figures made of both gold and ceramic.

The goldworkers of Tumaco made good use of the properties of platinum, and by hammering the gold integrated the two metals with amazingly advanced techniques (Cardale de Shrimpff, Marianne: 1982; Reichel-Dolmatoff, Gerardo: 1981), whereas European goldsmiths only began to use platinum three centuries after the Spanish Conquest.

Calima

The valleys formed by the many rivers that flow down from the Western Cordillera into the Pacific were the means of entry into the densely populated Andean lands. Several centuries before Christ, sedentary groups cultivating maize settled along the course of the Calima and Dagua rivers. Known as the Ilama culture, it marked a long process of development that would lead to a substantial growth in population.

Between the first centuries A.D. and the year 1,000, groups of the Yotoco culture transformed the hills and valleys by making terraces for housing, fields for their crops, drainage canals, and an extensive network of trails that linked with the jungles on the eastern slopes of the Cordillera and with the valley of the Cauca river (Bray, Warwick; Leonor Herrera and Marianne Cardale de Schrimpff); these works give evidence of an efficiently organized society with centralized political power. In the cemeteries, tombs of varying sizes, some with rich offerings of gold and pottery, indicate a well-defined social hierarchy.

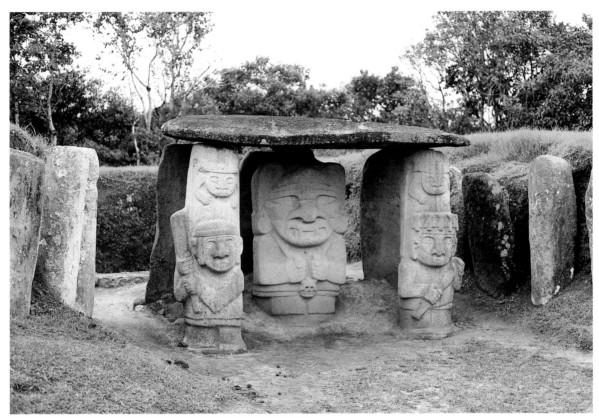

Cist grave with tomb guardians, San Agustín Region.

Although the metalworking techniques may have been known in the area from centuries before, it is to this period, spanning over ten centuries, that most of the Calima gold belongs. Complex, spectacular attire in which the ostentation of the great quantity of gold used is outstanding: diadems, nose ornaments, ear pendants, breastplates and pectorals, necklaces and bracelets, and large-sized bangles (Pérez de Barradas, José: 1958) must have left uncovered only a very small part of the body of the wearer. Impassive funeral masks, figures of men and animals, and spoons and containers are some of the objects that accompanied these golden beings to their graves. There are pieces made of gold leaf, with a profusion of hanging discs that tinkled when the person wearing them moved. Faces of identifiable personages, wearing nose ornaments depicting the same faces, decorate some of the pieces, giving a disquieting feeling of repetition into infinity.

These people used their gold to make *poporos,* vessels in which to keep the lime obtained from pulverized shells, which they mixed with toasted coca leaves. This mixture, through chemical reaction, produced the stimulating effects of a narcotic drug, which played an important role among the prehispanic societies as part of the traditional rites performed when the community congregated, thus maintaining the cohesion of the social group.

The goldworkers of the Calima area also used casting techniques, making pendants representing lavishly adorned men and pins that incorporated birds, monkeys, and masked figures.

San Agustín

This region, well known because of its vast archaeological remains, is located in the Colombian Massif, where the Andean Cordillera divides into two ranges. The sources of many rivers, including the

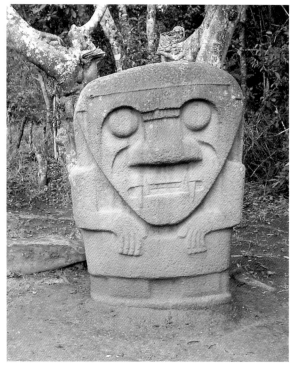

Fanged mythic figure, San Agustín Region.

The earliest gold pieces of San Agustín were made around the year 40 B.C. (Plazas, Clemencia and Ana Maria Falchetti: 1983). Outstanding among the goldwork from this area are diadems, bracelets, and large pectorals (both hammered and embossed), assembled figures, and beads cast in the shapes of men, animals, and double-spouted jars.

Tierradentro

During the period of the development of the San Agustín region, there were contacts with the neighboring area of Tierradentro, located in the basin of the Páez and Negro rivers and other tributaries of the Magdalena river. This may be appreciated in the features of some of the Tierradentro goldwork, which has very similar iconography to that of the San Agustín statues, as well as in the resemblance of the pottery and sculpture. Tierradentro is well known for its monumental tombs with underground chambers, reproducing the interior of the houses, painted with geometric and zoomorphic figures in black and red, where funeral urns were placed with bones exhumed from previous burials.(Chaves, Alvaro and Mauricio Puerta: 1973-79; Chaves, Alvaro and Mauricio Puerta: 1980).

But it is in simple shaft tombs that gold pieces outstanding for their technical quality were found: masks, ear pendants, and pectorals, some of which were decorated with embossed jaguars, with the same protruding fangs as those portrayed in the San Agustín sculptures.

Nariño

Around the period 600—1000 A.D., the highlands of Nariño, in the southernmost part of Colombia, were inhabited by a group that produced goldwork related—by its technology and some of the forms—to the metalworking tradition of

Magdalena and the Cauca are found there.

In the last centuries B.C., the inhabitants of San Agustín gradually populated an area of 500 square kilometers, as evidenced by traces of substantial earthworks (Duque Gómez, Luis: 1964; Duque Gómez, Luis and Julio César Cobillos: 1979; Falchetti, Ana Maria: 1976). Terraces and canals alternate with artificial mounds covering monumental tombs lined with stone slabs, sarcophagi, statues, and occasional rich gold offerings. Theirs was a complex society whose force and aggressivity is expressed in the features of the statues: Armed warriors with the heads of their enemies as trophies and men richly attired, alternate with jaguars, birds of prey, and serpents.

The great regional prosperity of San Agustín lasted for over one thousand years, enhanced by various external influences, owing to the geographical position of the Colombian Massif with its natural means of access to the Pacific coast, the Amazon region, and the Cauca and Magdalena valleys.

Colombia's southwest. Known as Capulí, this culture extended through the Andean region in northern Ecuador and maintained strong trade links with the inhabitants of the Pacific coast and the Andean foothills (Uribe, María Alicia: 1988; Uribe, María Victoria and Roberto Lleras: 1982-83).

In the lowlands, they used to procure coca leaves, the use of which was depicted in the famous ceramic *coqueros,* or chewers of coca. Portrayals of men and animals, vessels of every shape and size, and rich gold offerings, were buried in shaft tombs with a side chamber that were sometimes as much as thirty to forty meters deep.

Circular ear ornaments embossed with human faces and the heads of jaguars, crescent-shaped pendants decorated with geometric designs, monkeys, and other animals welded onto them, nipple shields, pectorals in the form of birds, and necklace beads are all characteristic of the Capulí gold (Plazas, Clemencia: 1977-78). This work is closely linked to later metalworking developments on the coast of Ecuador: Milagro, Quevedo, and Manta, where jaguar-shaped ear pendants have been found that bear a close similarity, despite maintaining a local style. The relationship between the people of the Ecuadorian coast and the Nariño highlands through the Guayas river appears to have been maintained throughout their history, and this is reflected in the existing metalwork.

In the highlands of Nariño, the Spanish conquered the Pastos, descendants of a group known to archaeologists by the name of Piartal (Uribe, Alicia: 1988), who had occupied the area since the eighth century A.D. They built their houses on the edges of the mountains, terraced the hillsides to increase their crops, and developed a sophisticated technology for making objects of clay and wood, wigs from human hair, textiles, as well as unique goldwork, different from any other in Colombia (Plazas, Clemencia: 1977-78).

In contrast to the metalwork in the rest of Colombia's Southwest, these craftsmen used *tumbaga* with high proportions of copper, which they subsequently covered with layers of surface gilding. The mastery of their art can be particularly appreciated in the rotating discs made by hammering a metalsheet until an even thinness was achieved. The gilded surface was radially polished, and with different metallic colors and textures obtained through the application of organic acids, everchanging reflections of light were achieved. Revolving, these discs produced unusual effects to the viewer, and must have been used in mythical and ritual contexts.

The designs of almost all the pieces are non-figurative and show a mastery of form and aesthetic sensibility. This is evidenced by the diadems that resemble feathers, the plaques of different shapes for sewing onto textiles, and the nose pendants of rectangular and other shapes, which, according to their decoration, changed the facial expression of the person wearing them.

Tolima

This region—located in the tropical valley of the middle Magdalena, Colombia's principal river—was an important route for trade and human migrations. Gold, extracted from the rich alluvia of the river Saldaña and the adjacent areas, was a major trade commodity for supplying metalworkers from neighboring districts.

The presence of these alluvial deposits was responsible for the local production of gold pieces at the time of the prosperity of Colombia's Southwest. The existence of similar pieces in the Magdalena and Cauca valleys and in the Calima area bears witness to the cultural exchange between these regions (Plazas, Clemencia and Ana María Falchetti: 1983).

The Tolima goldwork boasts large pectorals of cast and hammered gold, representing schematic, winged human beings, necklace beads in the shape of stylized men or animals, and pendants of cast gold representing fantastic creatures and insects.

Quimbaya

In the overall context of prehispanic metalwork in Colombia, the Quimbaya region, situated in the temperate climate of the middle-Cauca valley, may be considered as a transition area. It embodied some of the metalworking traditions of Colombia's Southwest and yet at the same time had strong links with the goldsmiths in the north. Before the year 1000 A.D., the region was inhabited by a group who produced the goldwork known as Classic Quimbaya, remarkable for its technical skill (Bruhns, Karen: 1978; Pérez de Barradas, José: 1966; Plazas, Clemencia: 1987). Inhabiting a district where gold was less abundant than in the rivers flowing into the Pacific, the goldsmiths made wider use of gold and copper alloys. With unrivaled mastery, they perfected casting techniques to make solid pieces as well as hollow vessels that required the use of a core support.

Outstanding are the objects that represent expressively realistic human beings, gourds, and other fruits, also the necks of the *poporo* lime flasks made to fit onto real gourds. Pins and other pieces were made in several castings or with different gold-copper alloys, which give the finished object a vivid appearance due to the different nuances of color.

As regards the casting techniques and the presence of pins and similar pieces, we can observe a close relationship between the Quimbaya and the Calima regions. Although the Classic Quimbaya goldwork was centered mainly in the

middle-Cauca valley, similar pieces have been found in the middle-Magdalena basin and in the Antioquia Massif (Castaño, Carlos: 1988). Indeed, this goldwork was part of a wider transition whose influence was felt in the center and north of Colombia and in Central America.

Features similar to those of the Classic Quimbaya goldwork appear in human figures produced in different parts of this extensive area; they are distinguished by their smooth forms and their peaceful expressions with half-closed eyes, and by their ornaments such as diadems, multiple ear pendants, the ligatures on their arms and legs, and the spirals—like stylized ears—on the sides of their heads (Bray Warwick: Unpublished; Cooke, Richard and Warwick Bray: 1985; Falchetti, Ana María: 1987).

Later-Day Gold in the Southwest

The cultures in the southwest achieved their greatest stability before 1000 A.D. After this, there was a period of decline, and a different cultural tradition spread throughout these regions. Some authors associate this new wave with the influx of Carib-speaking peoples from the Amazon basin, who populated the islands and coastlines of the Atlantic and then proceeded to settle in the valleys of the Magdalena and Cauca rivers (Pérez de Barradas, José: 1966).

The goldwork of this later period is distinguished by the predominance of *tumbaga*, and by the techniques of casting and gilding through oxidation. Goldwork became popular, and pieces of homogeneous techniques and styles were made in widely spread areas. Typical are spiral, half-moon, and circular-shaped nose ornaments; pendants in the form of frogs, reptiles, and snails; and cast heart-shaped or round pectorals with geometric, anthropomorphic, and zoomorphic designs (Plazas, Clemencia and Ana María

Falchetti: 1983; Plazas, Clemencia and Ana María Falchetti: 1985).

Numerous groups with their own identity but linked by a common cultural substratum occupied the Cauca river valley and the Calima region (Bray, Warwick, Leonor and Marianne Cardale de Schrimpff: 1, 2, 3, and 4; Bruhns, Karen: 1976), where they remained until the Spanish Conquest (Duque Gómez, Luis: 1970). They lived in round huts grouped together into hamlets. They buried their dead in shaft tombs with a side chamber, forming large cemeteries, and they used funeral urns. Their pottery has various characteristics in common, such as the predominance of resist painting and the similarity among the numerous anthropomorphic figures and vessels that show the same simplification of features.

In the area of San Agustín, as well, one observes in this later period a break with the older traditions and the emergence of new influences, possibly coming from Amazonia (Duque Gómez, Luis and Julio César Cubillos: 1979; Reichel-Dolmatoff, Gerardo: 1975), while the upper Cauca river area, between Tierradentro, Popayán, and Puracé, was occupied by a little-known group that produced elaborate eagle-shaped pendants of *tumbaga*.

Accordingly, the groups inhabiting the Colombian Southwest after the year 1000 A.D. had very different cultural manifestations from those who, centuries before, had been responsible for the great flowering of this region.

GOLD FROM THE NORTH

Sinú, Tairona, and Muisca
These archaeological areas, located, respectively, in the Caribbean plains and in the mountainous regions of central and northern Colombia, shared metalworking traditions with Panama and Costa Rica, in Central America. There, pre-hispanic goldsmiths stressed the use of *tumbaga*, lost-wax casting, and gilding through oxidation.

Between the first centuries A.D. until around the year 1000, techniques, shapes, and ideas were transmitted from one region to another. Pendants and pectorals in the form of two-headed birds and animals with raised tails are some of the pieces then made in many goldworking areas of this extensive territory (Bray Warwick: Unpublished; Cooke, Richard and Warwick Bray: 1985; Falchetti, Ana María: 1987; Uribe, María Alicia: 1988). In the same period, the influence of the Quimbaya goldwork was present, with considerable influence upon the regional styles—Sinú, Muisca, and Tairona—that were already evolving at that time and which were to become established in the north, once the relevant societies had achieved greater stability and prosperity.

Sinú: The Gold from the Caribbean Plains

The tropical plains on the Caribbean are characterized by a variety of micro-environments and resources available for the livelihood of man: lands bordering rivers and marshes, natural estuaries, savannahs, and forests offered varied fauna and fertile soils for agriculture.

In this region as well as in other low-lying areas of the American tropics, the efficient exploitation of these natural resources and the planting of tubers and other tropical crops led to the establishment of stable, mixed-economy systems that allowed the emergence of more and more complex societies. These developments reached their peak with the Zenús, who inhabited the lowlands in the vicinity of the Sinú, San Jorge, Cauca, and Nechí rivers.

In the sixteenth century, when the Spanish conquistadors first explored the Caribbean basin, the Zenús lived in the Sinú and San Jorge valleys,

with Finzenú and Yapel being the major economic and political centers.

According to Indian tradition, as recorded in the chronicles of the Spanish Conquest, Finzenú and Yapel were the survivors of an old socio-political organization that had seen its climax centuries before the arrival of the Spaniards. The territory of the Great Zenú had then been divided into three provinces governed by chieftains of the same lineage: The Zenufana, located close to the gold deposits of the lower Cauca and Nechí, was the principal one, followed in importance by the Finzenú, in the basin of the Sinú river, and lastly by the Panzenú, which extended along the San Jorge valley. Archaeological studies have made it possible to establish that, between 800 B.C. and 1000 A.D., the floodable depression of the lower San Jorge was drained by means of a network of artificial canals covering 500,000 hectares; this made it possible to take full advantage of the fishing and farming potential of these soils fertilized by sediment. A numerous, largely rural population, settled along the waterways, both in isolated houses and in hamlets of up to six hundred inhabitants, built on artificial platforms that also housed the burial mounds where they interred their dead (Plazas, Clemencia and Ana María Falchetti: 1981). After the year 1000 A.D., the floodable area gradually became depopulated, marking the decline of the Great Zenú. The Zenús, however, survived in the savannahs and maintained economic control of the region.

At the time of the Spanish Conquest, there were still centers of specialized artisans in the Sinú basin whose products were traded throughout a large area. A community of goldsmiths lived in the town of Finzenú; specialists such as these produced objects homogeneous in technique and style, which have been found in burial mounds scattered throughout the territory of the Great Zenú (Falchetti, Ana María: 1976).

Lavish use of gold is observed in the abundance of fine pieces made by hammering gold sheet, which was then embossed on both sides to outline the design and put it into relief. This process was used in making spectacular breast shields and costumes, as well as necklace beads and many more simple ornaments. Gold was also cast, and sometimes mixed with a low proportion of copper to produce pieces in *tumbaga*, which were subsequently gilded on the surface. The cast objects are heavy and solid, and often large. This was the case with the elaborate staff-heads adorned with figures of men or animals.

Threads, braids, circles, and spirals of cast filigree decorate most of the pieces, and the same technique, distinctive in the Zenú goldwork, was used to make semicircular ear ornaments decorated with circles and figures of eight in thick filigree (Falchetti, Ana María: 1976; Plazas, Clemencia and Ana Maria Falchetti: 1985). These Zenú goldsmiths also depicted with great realism the fauna of their savannahs and marshes. Some truly splendid species predominate: birds with their beautiful plumage accentuated by open filigree work, the crest made of cast gold threads, indicating the desire to express the outstanding features of each creature.

The chronicles narrate that there was a cemetery at Finzenú destined for priests and chieftains of the three Zenús. They were required to be buried there, or at least a part of their gold interred there as an obligatory tribute. The burial mounds, the size of which depended on the social prominence of the deceased, were built communally during regional festivals. Pieces of pottery and probably of gold were made specially for these events. In the ceremonial center of Finzenú there was also a great temple, with twenty-four wooden idols covered with gold leaf, where the community deposited its offerings. Metal pendants decorated the walls, and the surrounding trees were hung with golden bells.

There were also important cemeteries in the basin of the San Jorge river. There, numerous mounds as much as six meters in height, contain multiple burials, a large number of offerings and sumptuous gold pieces. The proximity of cemeteries with smaller burial mounds, containing few pieces of pottery or gold offerings, indicates a social differentiation in funeral practices (Plazas, Clemencia and Ana María Falchetti: 1981).

Gold, used as adornment and symbolism as well as for religious and funeral offerings, also played a significant part in ceremonial rituals, which helped to maintain the social cohesion of the Great Zenús population. Gold enhanced the prestige of chieftains and priests, privileged individuals who represented the unity between the sacred and the social in this community where political, economic, and religious power were closely linked.

The influence of the Zenús was felt as far away as the Serranía de San Jacinto, the chain of mountains separating the plains of Atlántico from the Caribbean coast. In the sixteenth century, there existed a dense native population that used to bury their dead in urns and which produced metalwork showing a certain Zenú influence. There were numerous staff-heads decorated with the small figures of musicians, or men carrying gourds, and also figures of different animals, including species particular to the wooded, mountainous surroundings, as well as fauna typical of the swamps and marshes. Cast filigree work was also used to decorate some pieces and to make large numbers of ear ornaments of different shapes and sizes.

Technologically, the goldwork from the highlands of San Jacinto is typified by the use of *tumbaga* of a low gold content, as well as casting and gilding. One notices great versatility in the way personages and animals were depicted: Whereas the figures decorating the staff handles are very naturalistic, the human figure was usually represented in an extremely stylized manner. A large number of relatively small, crudelymade trinkets were also mass-produced for general use. Despite its local character, this highland goldwork shows varying influences. The raw material itself indicates links with the Tairona area, an outcome of exchanges between groups with different cultural origins (Falchetti, Ana María: 1987).

Tairona and Muisca:
The Gold of the Chibcha-Speaking Groups

At the time of the Spanish Conquest, the Sierra Nevada de Santa Marta in northern Colombia and the Eastern Cordillera of the Andes, now the departments of Cundinamarca and Boyacá, were inhabited, in relative splendor, by the Chibcha-speaking Tairona and Muisca societies, both of which had a strong goldworking tradition. Living in mountainous regions and belonging to the same linguistic family, they were linked by a common cultural origin, despite differences in many aspects of their socio-political organization and material culture.

The widespread use of *tumbaga*, an alloy of gold with a large proportion of copper, indicates the short supply of gold in both regions. In effect, virtually no gold is found in the highlands of the interior or in the Sierra Nevada de Santa Marta; the gold was obtained through barter with people from the lowlands. The Muiscas and the Taironas were societies that attributed different functions to gold, though their attitude towards the metal itself was essentially the same. Similarities and differences may be established on the basis of the actual pieces available and of the associations reached according to the places where they were found, the techniques used, and the figures depicted (Plazas, Clemencia and Ana María Falchetti: 1985).

Tairona

Since the first centuries A.D., the coastal areas north of the Sierra Nevada de Santa Marta were inhabited by ancestors of the Taironas. These groups were familiar with metalworking techniques and had links with the cultural traditions that covered a large area of west Venezuela, northern Colombia, and the south of Central America (Bischof, Henning: 1969; Bischof, Henning: 1969-b; Oyuela, Augusto: 1985).

The Taironas reached their maximum splendor after the year 1000 A.D., when dense populations were grouped together into a number of urban centers (Bischof, Henning: 1969-b; Cadavid, Gilberto and Luisa Fernanda Herrera de Turbay; Reichel-Dolmatoff, Gerardo: 1954). More than two hundred Tairona settlements are known at present, dispersed from sea-level up to an altitude of 2000 meters, notable for their architectural and engineering stoneworks (Cadavid, Gilberto and Luisa Fernanda Herrera de Turbay). Settlements of different sizes reflect political hierarchies, with larger centers controlling a series of smaller ones, through an elite formed by chieftains and a powerful priestly caste. Tairona goldwork consists of thousands of ornate, symbolic pieces showing men and animals mixed in a vivid imagery of deep religious significance (Plazas, Clemencia: 1987).

The Taironas used the lost-wax technique in casting; each mold was unique and very elaborate. The pieces were three-dimensional and, once taken out of the mold, all residue was removed, the pieces were then polished, gilded, and given a perfect finish.

The Tairona pieces were made for repeated use, undoubtedly during rituals. The diadems, nose ornaments, the pectorals, and necklaces show considerable wear on some of their surfaces; the rings for hanging the ornaments appear worn to the point of becoming quite fragile. Many Tairona pendants represent human figures with animal features: The bat/men, jaguar/men, bird/men, may indicate a desire to appropriate the powers of these animals and to be able to dominate them. Nose ornaments, earrings, diadems, and other items served to exaggerate and distort the facial features of the person wearing them and at the same time to imitate the characteristics of a certain animal. The bat/man was made to look like a bat by means of tubular nose ornaments that raised his nose, and by diadems representing the bat's ears (Legast, Anne: 1987). Some pieces occasionally show masks with the fangs of the animal prominently displayed. Nose ornaments in the form of a "butterfly," very common in the region, altered the face by transforming the mouth into a snout of a different color. This might have been a way of representing a jaguar/man.

Other animal attributes are often associated with the main figure. Thus, the bat/man has eagles over his head, or a belt in the shape of a two-headed serpent with a forked tongue; the same animals are also incorporated in pectorals, lip plugs, and ear ornaments. The elaborate designs of Tairona pieces are consistent with their symbolic purpose. These striking human beings with animal attributes may identify specific social groups with a mythical and ancestral relationship to certain animals.

Muisca

The Muiscas, a people with a rural way of life, settled in the highlands of the Eastern Cordillera some time after 600 A.D. (Archila, Sonia: 1985; Castillo, Neila: 1984). The scattered population of farmers, as well as the inhabitants of the villages, were controlled by local chieftains who in their turn obeyed higher chieftains. The two supreme chiefs, the Zipa and

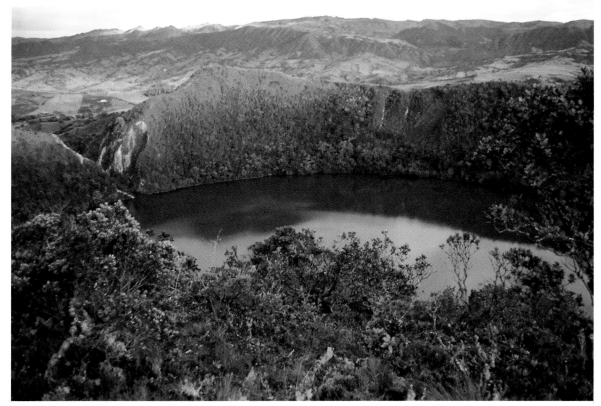

Lake Guatavita, Sacred Lagoon, Muisca Region.

the Zaque, aspired to domination over the south zone and the north zone of the Muisca territory, respectively, in a policy of expansion that was still in process in the sixteenth century. Thanks to both the study of archaeology and the written sources of the Spanish conquest and colony, we have detailed information on the everyday life and economic activities of the Muiscas.

Specialized centers produced varied goods both for household use and for barter within and without the territory; for example, on the temperate hillsides of the Cordillera, cotton was grown and used to weave blankets, belts, and pouches decorated with geometric designs. Many communities made pottery for household or ceremonial use; elsewhere, metalworkers made trinkets for adornment and offerings, and emerald, copper, and salt mines were exploited. The inhabitants of Zipaquirá, Nemocón, and Tausa, where there were salt deposits, used earthenware vessels called

gachas to evaporate the water from the salt in order to make the salt blocks that were traded as far as 300 kilometers away, along the Magdalena river valley (Cardale de Shrimpff, Marianne: 1982). Through barter the Muiscas obtained the gold to supply their goldsmiths.

The many somewhat crude Muisca gold objects suggest that they were in general use, produced in quantity to meet a wide demand for gold used for purposes of religious supplications. For the Muiscas, gold was closely linked with their religious cult. Though they made ornaments that accompanied them to their graves, most of the pieces found are small, rough figures, with all kinds of themes (Plazas, Clemencia: 1975). They were cast by the lost-wax process and sometimes were produced in quantity, with the aid of a matrix carved in a soft stone, to obtain designs imprinted on both sides (Long, Stanley: 1967). These matrices were used to impress the design in soft clay;

when the clay was dry, the inside of the mold was then lined with a layer of beeswax and again stamped with the stone matrix. The result was a wax mold, imprinted on both sides, which, made in quantity, could be used for casting as many pieces as were required. This method was used particularly for making necklace beads and occasionally decorations for large-size pectorals.

The human figures known as *tunjos* were generally not given any kind of finishing; they still retain the funnel and pouring channels and the surplus metal. In spite of this and the apparent naivety of the design, they are nevertheless perfectly suitable for the function for which they were made: The subject matter of the figure used for a votive offering was more important than any careful workmanship or the quality of the finishing. A careful observation of the *tunjos* and other imagery might lead us to conclude that there was a specific language, some specific conventions, embodied to pray for a miracle or give thanks for a favor granted (Plazas, Clemencia: 1975). Warriors, male figures dressed in an attire that surely indicts their rank, personages with instruments for taking narcotics, women with children, miniature versions of their different ornaments, condors, serpents, and jaguars clearly indicate certain types of offering for getting a specific benefit or for giving thanks for it. The language of the offerings is necessarily symbolic of many different things, where a certain figure—whether it is that of a warrior, a woman and child, an animal, or an adornment—symbolizes more than it literally depicts. Thus, an ornament may symbolically represent the wearer, and one part may represent the whole. Thorough knowledge would be required of the Muiscas' customs and conceptual systems to unravel the significance of these small details. Although the custom of the votive offerings is universal, the significance of the offering itself is conditioned by the symbolic

code established by the particular religion.

In addition to the craftsmen producing these rough objects, the Muiscas also had highly skilled goldsmiths. Some, like those from Guatavita, used to travel through the entire territory offering their services, while others settled down in their centers of production. One such center was probably Pasca, where numerous matrices and objects used in casting, polished stone slabs for working wax, pottery blowpipes for kindling the fire, as well as some gold pieces unique for their fine finish have been found.

The Muisca sanctuaries were located in remote sites of difficult access: cliffs, caves, and lakes, all places of great natural beauty. There the individual or communal offerings were deposited. Lakes were the principal offering sites, and the setting for great collective ceremonies, such as those that used to take place each year in Guatavita. Located in the vicinity of villages were other sanctuaries or temples, consisting of small straw huts, dark and gloomy (Cortéz Alonso, Vicenta: 1960). Inside, there were figurines made of gold, copper, cotton, or wood, decorated with emerald crystals and feathers, wrapped in cotton and placed in clay pots or gourds; these, in turn, were left inside a woven pouch that was hung in the middle of the hut or buried in the ground.

Religious customs of this kind required a caste of priests entrusted with the safekeeping and offering of the objects. Chronicles tell us that the priests received training for many years before they could perform these rites. They were responsible for the sanctuaries and for collecting the offerings after fasting with the donors.

The function of the Tairona ornamentation as symbolic and of the Muisca pieces as offerings are in fact two different manifestations of one common belief. This unity may be appreciated through mythology and through the vision of the world of the Chibcha groups that still live in

Sunset, San Agustín Region.

Colombia, such as the U' was (Tunebos) in the Sierra Nevada del Cocuy or the Kogis and the Ijkas of the Sierra Nevada de Santa Marta, who are descendants of the Taironas.

The Kogis do not value gold, metals, or gems as symbols of wealth and status. For them, gold is a symbolic potential of fertility belonging to the entire society. The Sun, the male principle, the supreme procreator, transmits its creative power to gold; that is why Kogi priests "recharge" their ancestral pieces and relics, passed down from generation to generation, by exposing them to the sun (Reichel-Dolmatoff, Gerardo: 1981). This also explains the reason for giving offerings.

Among the Ijkas, personal or communal offerings are made through the priest, who deposits them in special places, such as lakes. These sites are always located close to mountain peaks or cliffs embodying the spirit of the ancestors, transformed into stone by the coming of the sun. High lakes—where the offerings are laid, where the rivers that fertilize the lowlands are born—are the womb of Mother Earth, the female principle, fertilized by the Sun and fertilized once more by the gold, the male principle associated with the Sun.

Clemencia Plazas, Ph.D. Ana María Falchetti, Ph.D.
Director *Assistant Director*
Museo del Oro Museo del Oro

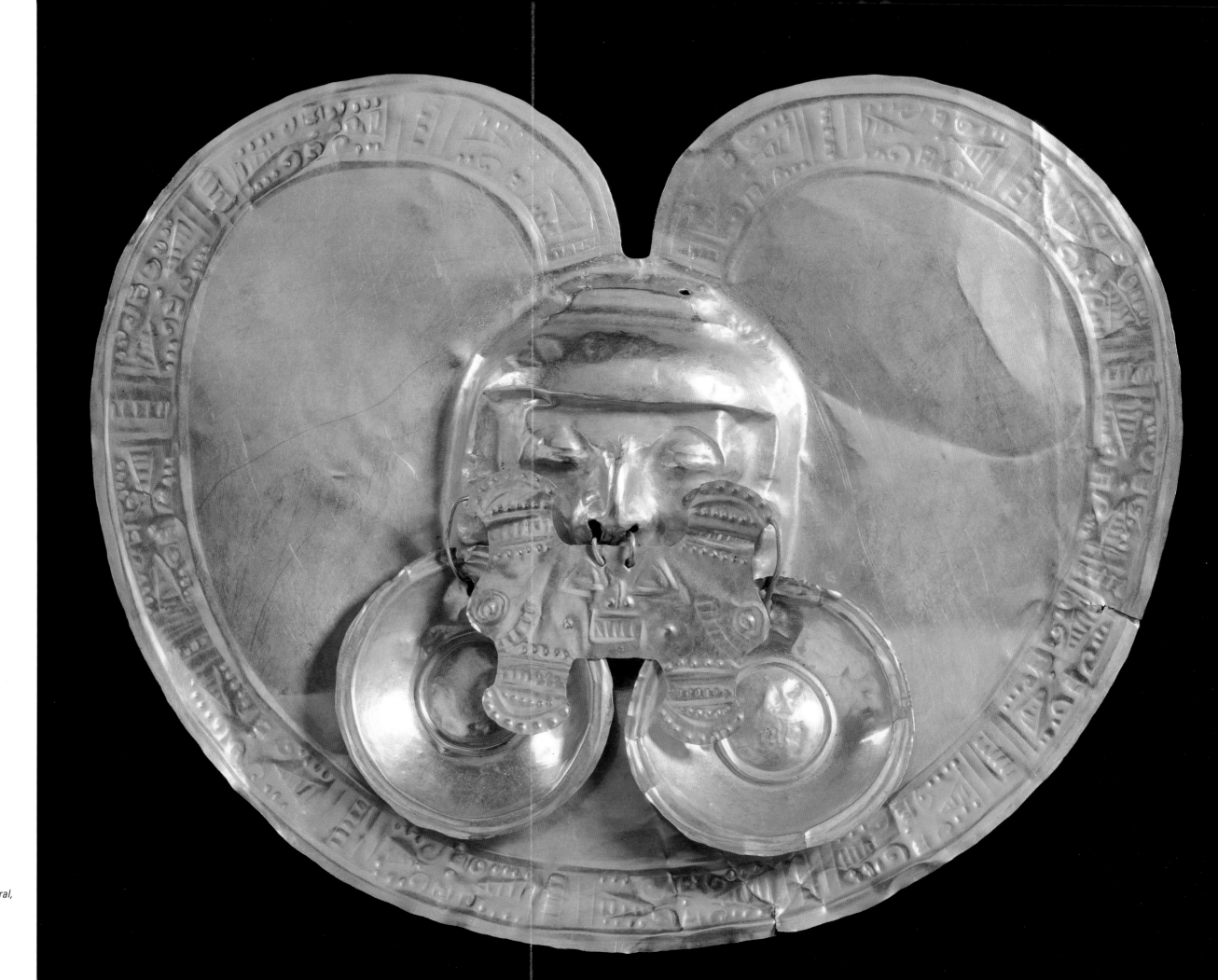

C2. *Heart-Shaped Pectoral,*
Early Calima Style.

The Calima region lies within the Department of Valle del Cauca and embraces the upper Calima Valley and surrounding areas of the Western Cordillera (Cordillera Occidental), as well as adjacent lands along both sides of the Cauca River. This region is naturally rich and fertile, with a mean annual rainfall of about 96.5 cm. (38 in.). The western part of the area is crossed by the Calima and Dagua rivers, while the Cauca flows through the eastern reaches, between the Western and Central Cordilleras.

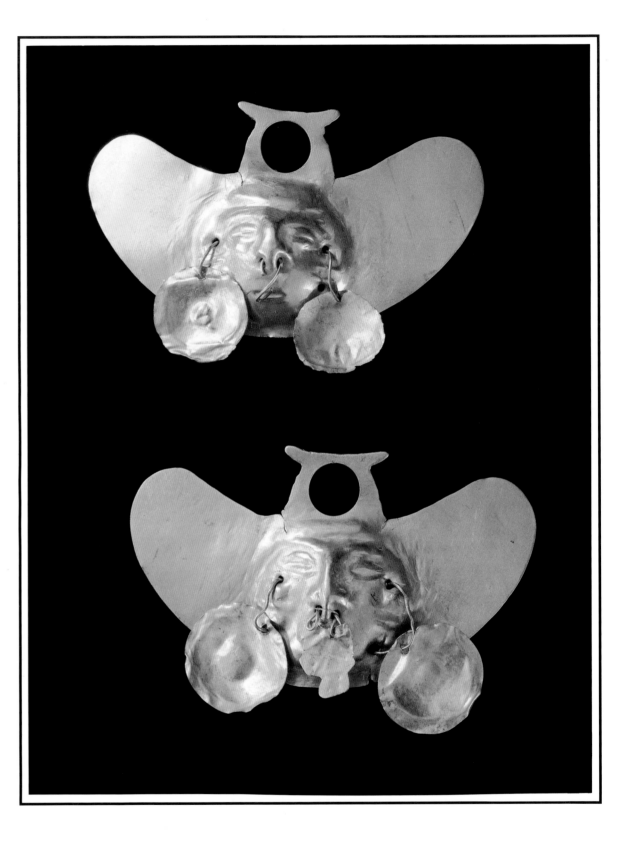

C1. *Pair of Ear Pendants,* Early Calima Style.

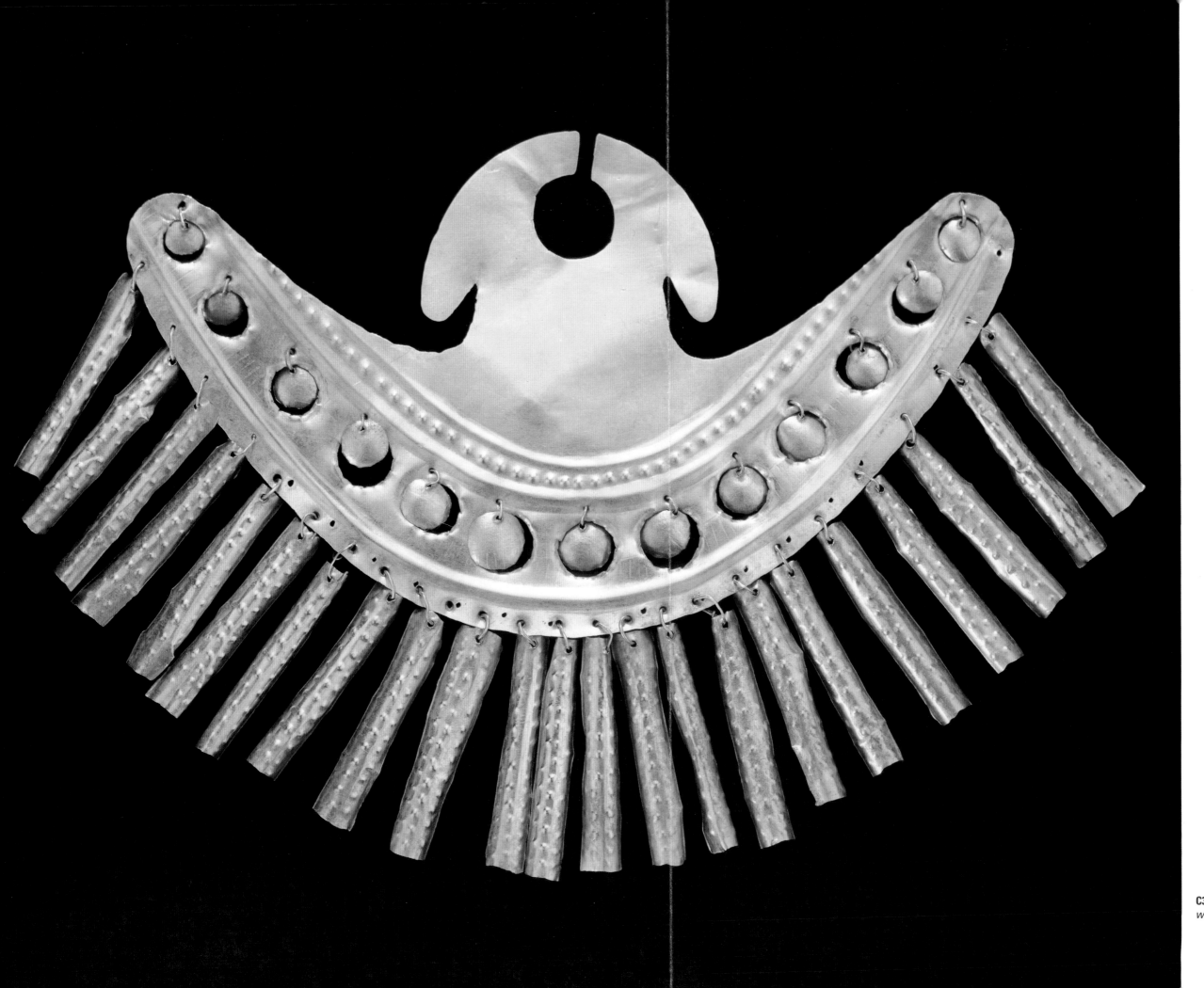

C3. *Wing-Shaped Nose Ornament with Danglers,* Early Calima Style.

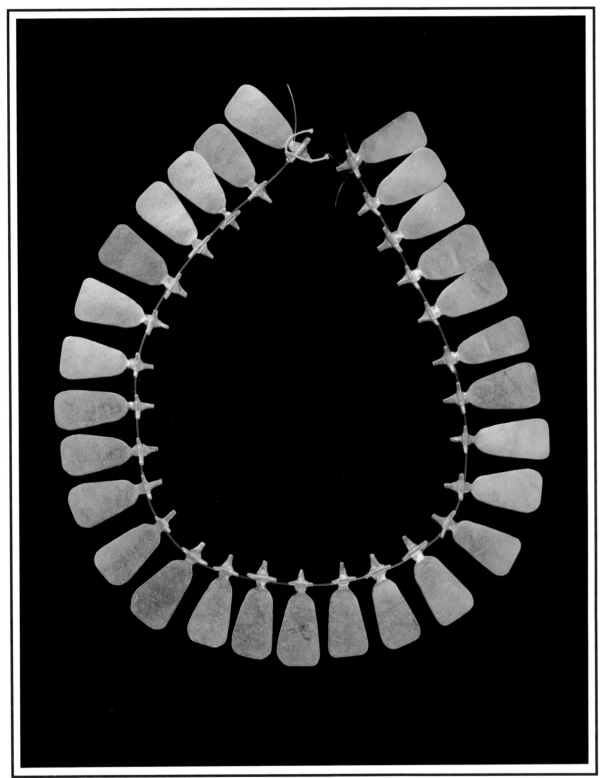

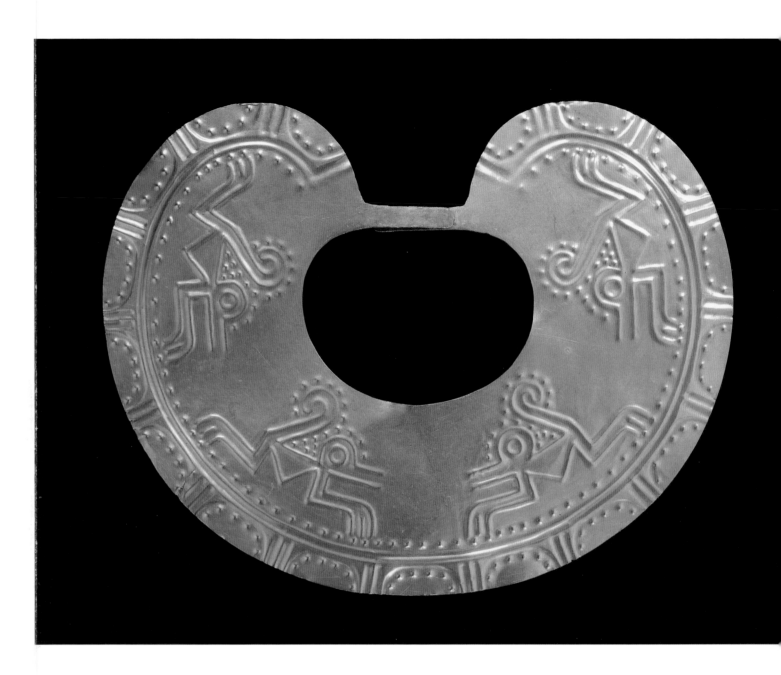

C4. *Necklace with Twenty-Eight Zoomorphic Pendants,* Early Calima Style.

C5. *Pectoral,* Early Calima Style.

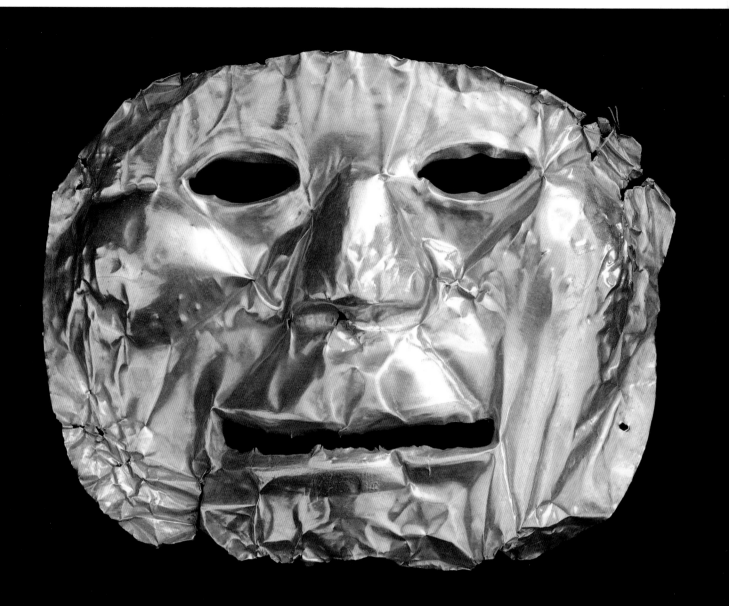

C6. *Human Face Mask,* Early Calima Style.

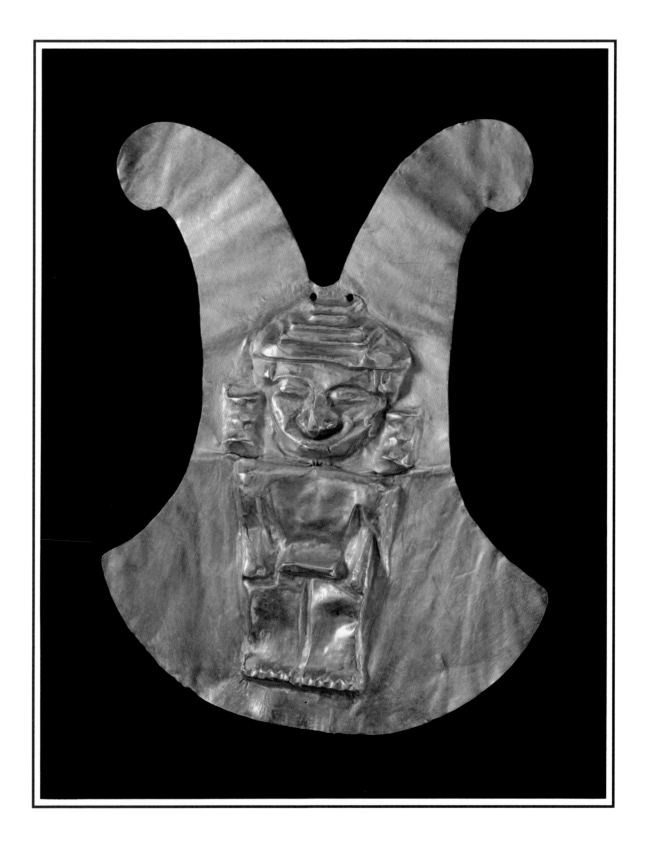

C7. *Pectoral with Human Figure in Relief,* Early Calima Style.

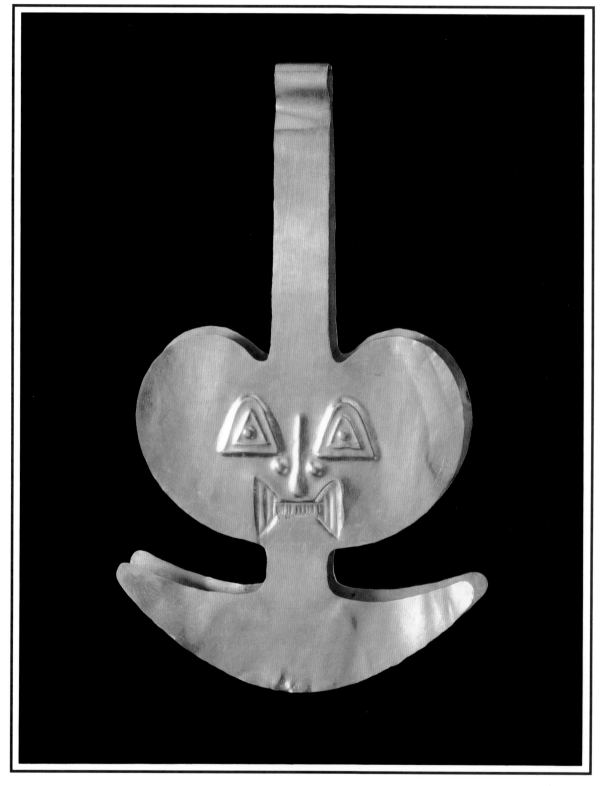

C8. *Tweezer-Shaped Pendant with Stylized Face in Relief,* Early Calima Style.

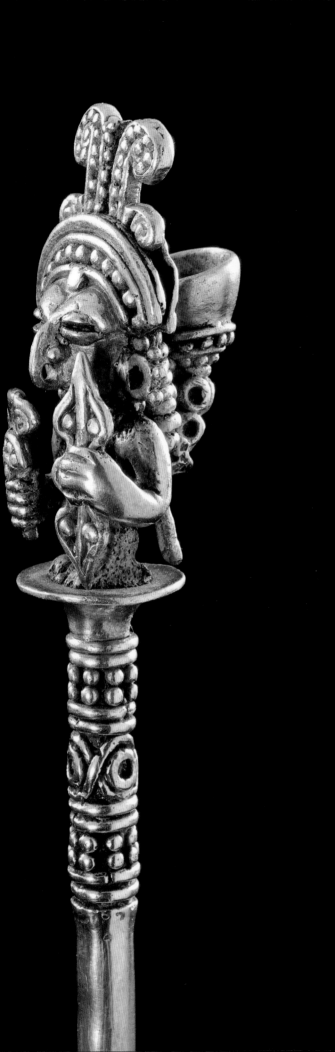

C9. *Lime Dipper Incorporating a Human Figure,*
Early Calima Style.

I mmediately to the north of the Calima Zone lie the archaeologically and artistically rich provinces of the Middle Cauca River region, which are climatically similar to the Calima Zone.

The term "Quimbaya," used in the popular literature, refers to the art and artifacts of a number of divergent prehistoric cultures found in the Middle Cauca River Valley and adjacent slopes and mountains of the modern departments of Quindio, Risaralda, Caldas, and southern Antióquia.

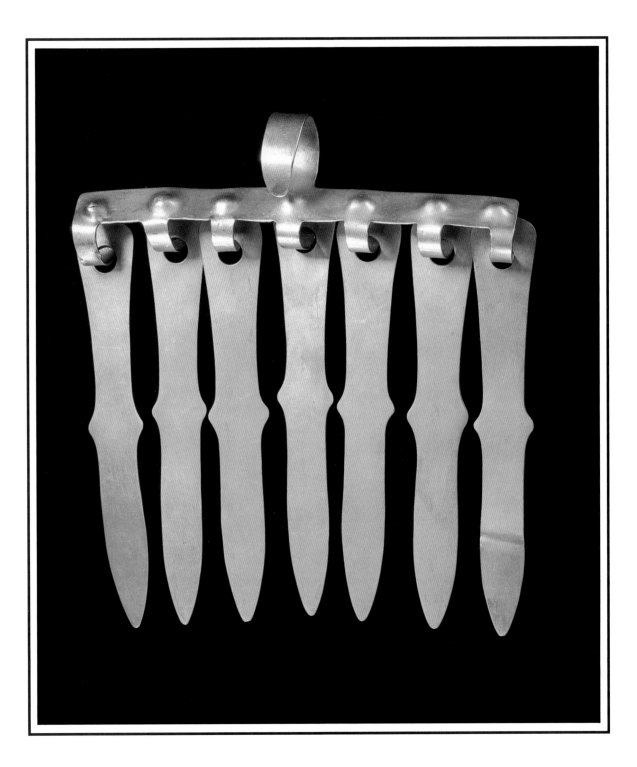

Q1. *Nose Ornament with Danglers,* Quimbaya Region.

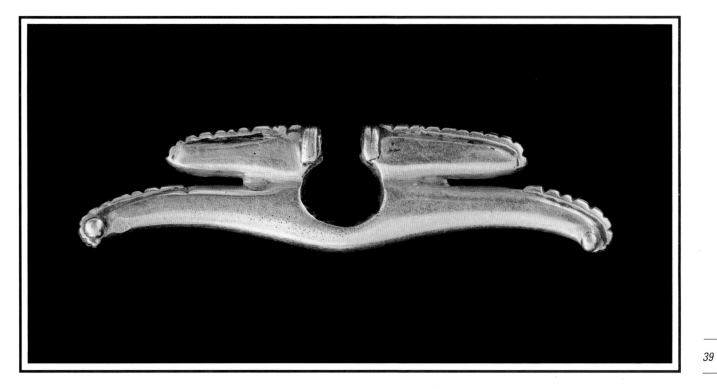

Q2. *Nose Ornament,* Quimbaya Region.

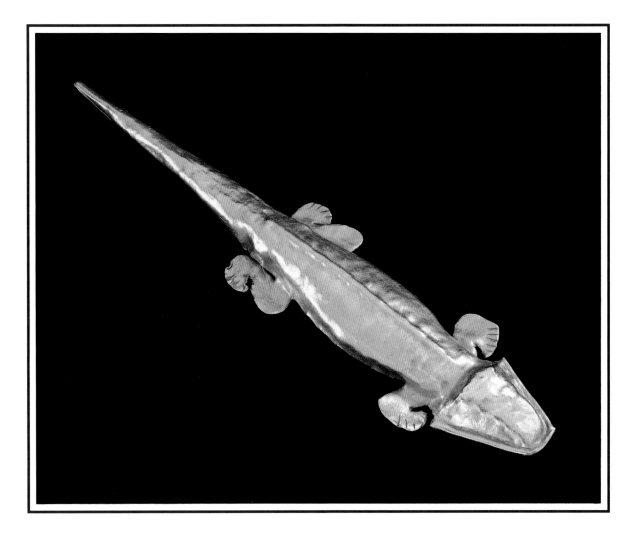

Q3. *Zoomorph in the Form of an Alligator or Lizard,*
Quimbaya Region.

Q4. *Face Maskette,* Quimbaya Region. ▶

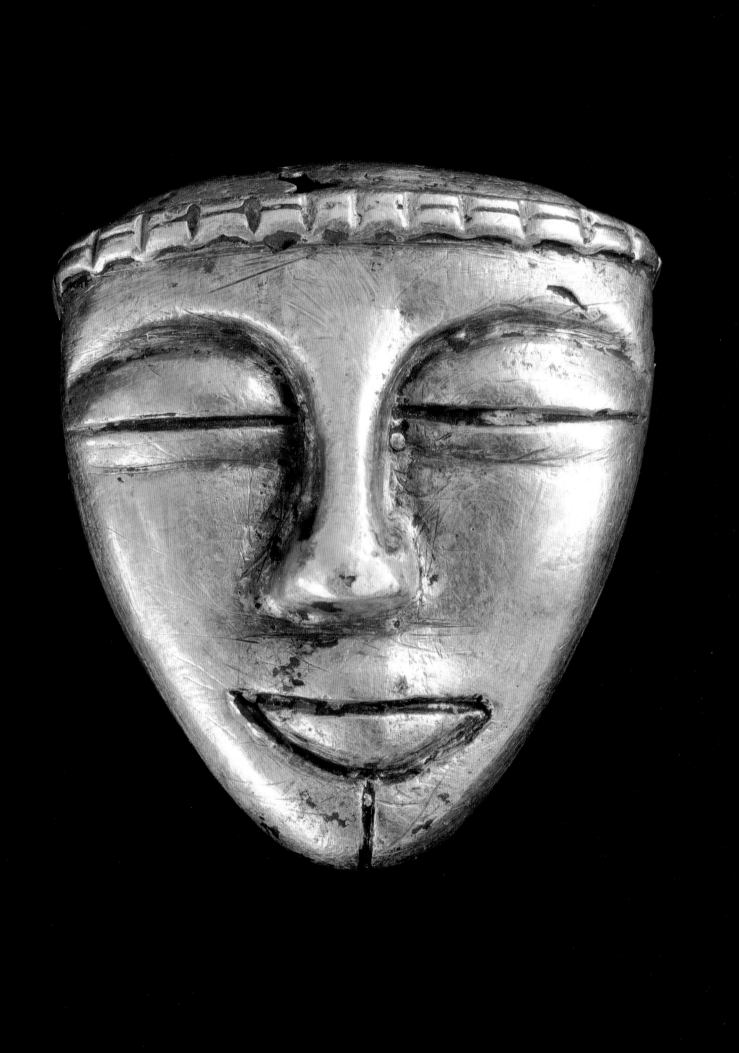

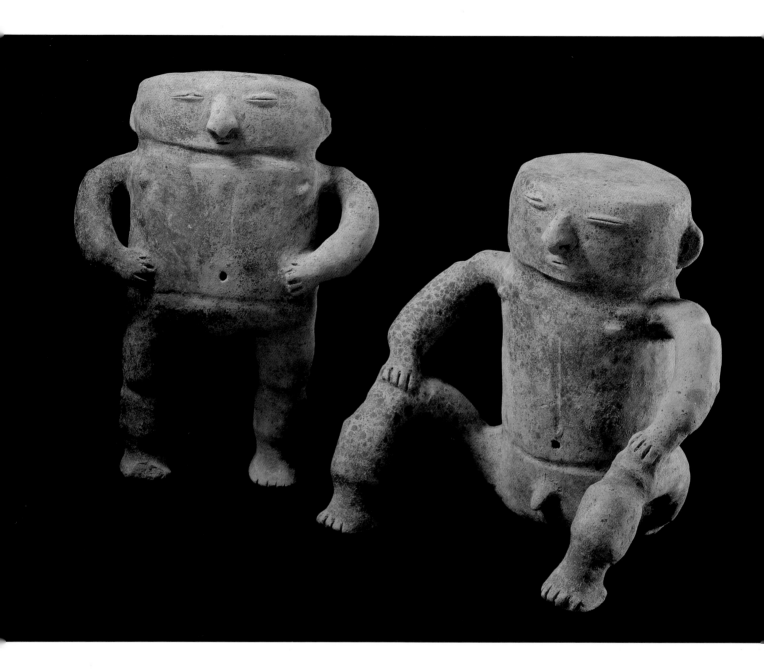

Q5. *Hollow Standing Female and Seated Male Figures,* Quimbaya Region.

ollowing the Cauca River northward across the Depart-
ment of Antióquia, one arrives at the northeastern
extremity of the Cordillera Occidental known as the
Cucilla del Mocho and the northwestern extremity of the Cordillera
Central. Here the great valley formed by the Cauca River ends,
while the river continues its course through a vast region of grassy
lowlands. This region is comprised of a broad flood plain coursed
by the meanders of numerous rivers, such as the Rio San Jorge, the
Rio Nechi, and the Rio Sinú. The topography is only occasionally
broken by an outcrop of highlands. The most prominent of these is
the Serrania de San Jacinto in the northern portion of the region,
between the Rio Magdalena and the Caribbean coast.

The San Jorge, Sinú, and Nechi Rivers were important
centers of culture in antiquity. The San Jorge River has its source
in a geological formation known as the Nudo de Paramillo, in the
Department of Córdoba, and ultimately joins a tributary of the
Magdalena River in the Department of Bolívar. The Sinú has its
source in the Department of Antióquia and empties into the
Atlantic in the Bay of Cispata. The river bifurcates near Cerete,
forming the Aguas Blancas (White Waters) and Aguas Prietas
(Dark Waters), which later unite at Lorica, continuing on to
the sea. The San Jerónimo range lies between the San Jorge and
Sinú rivers.

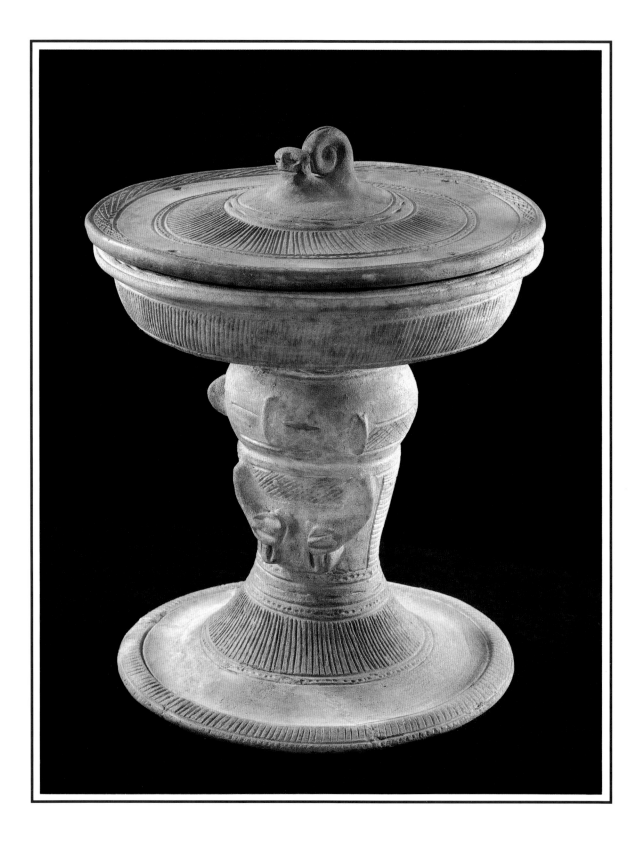

44

S1. *Ring-Based Stemmed Cup with Lid,* Sinú Region.

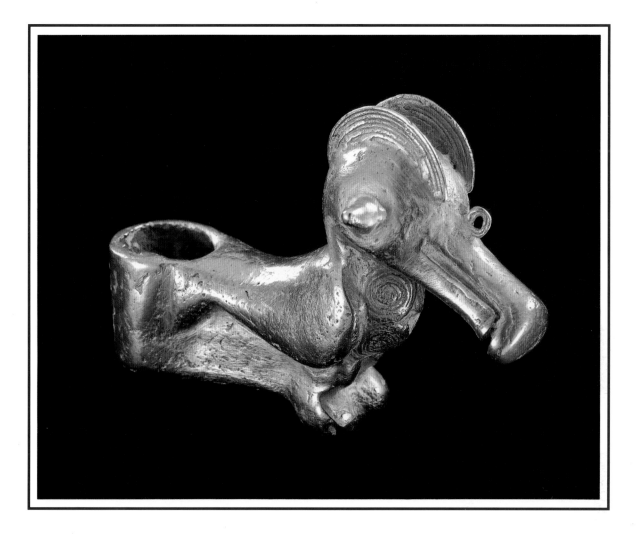

S2. *Staff Finial in the Form of a Bird,* Sinú Region.

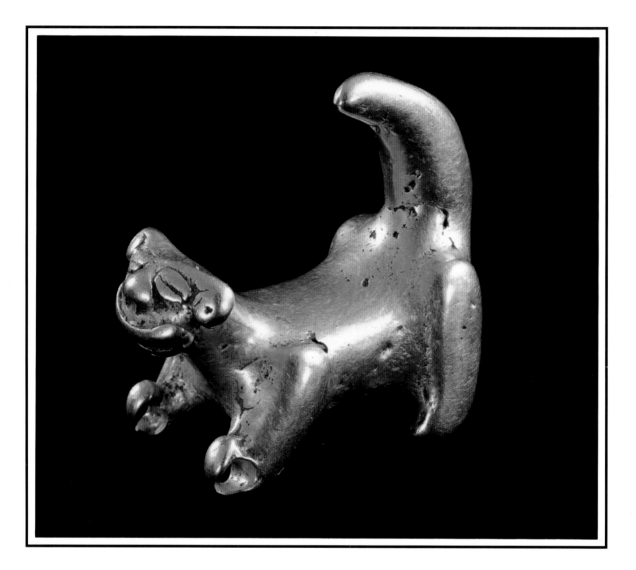

S3. *Zoomorphic Pendant,* Sinú Region.

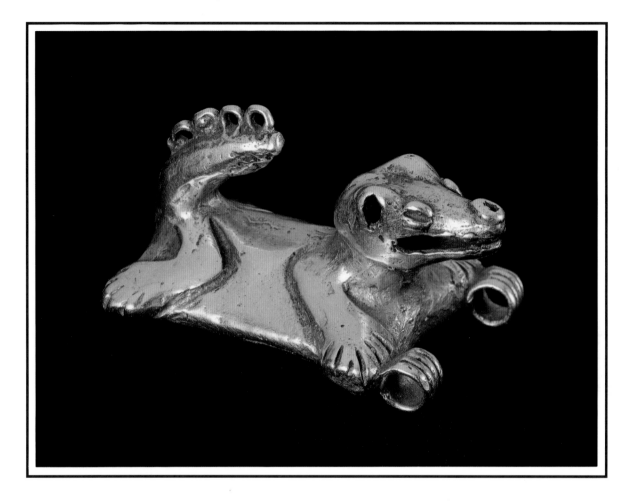

S4. *Zoomorphic Pendant,* Sinú Region.

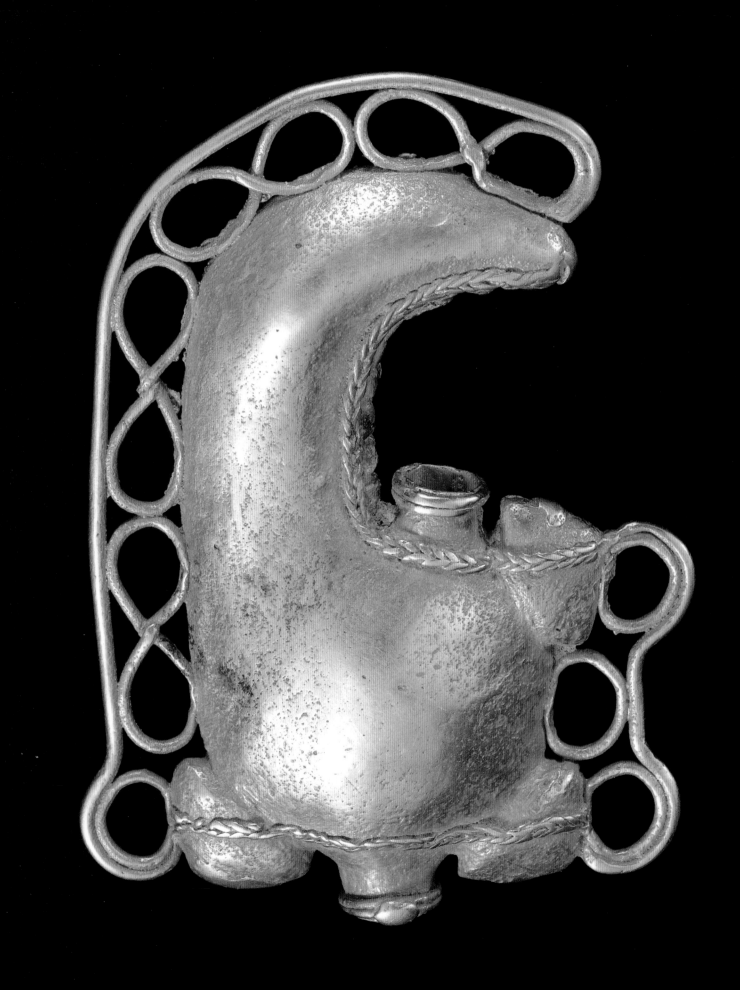

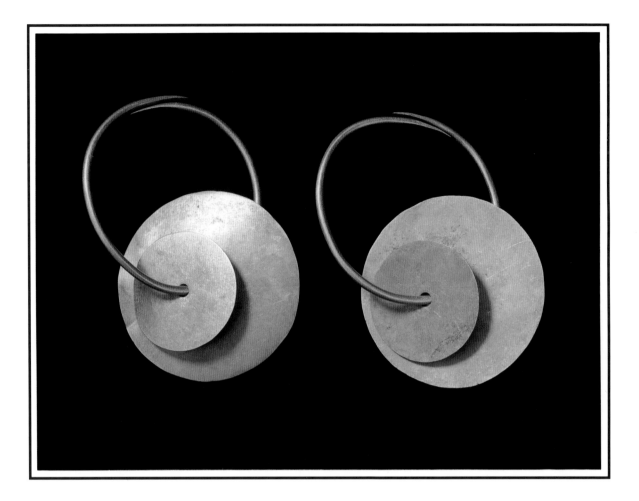

◀ **S5**. *Abstract Zoomorphic Staff Finial,* Sinú Region.　　　　**S6**. *Pair of Earrings with Disc Pendants,* Sinú Region.

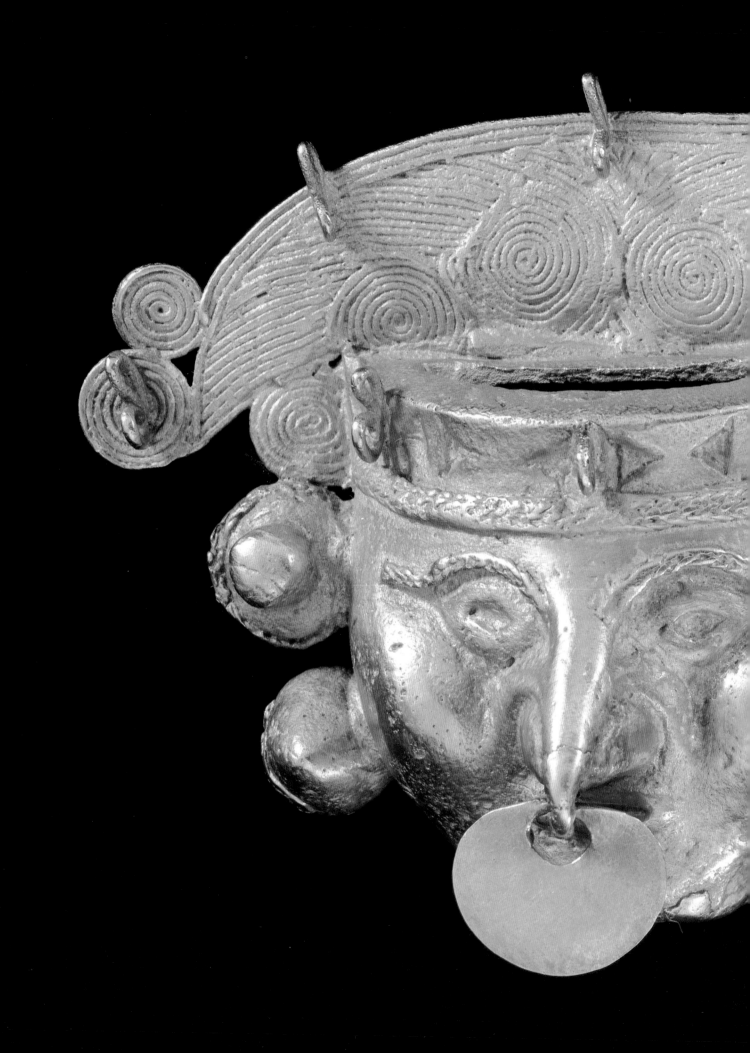

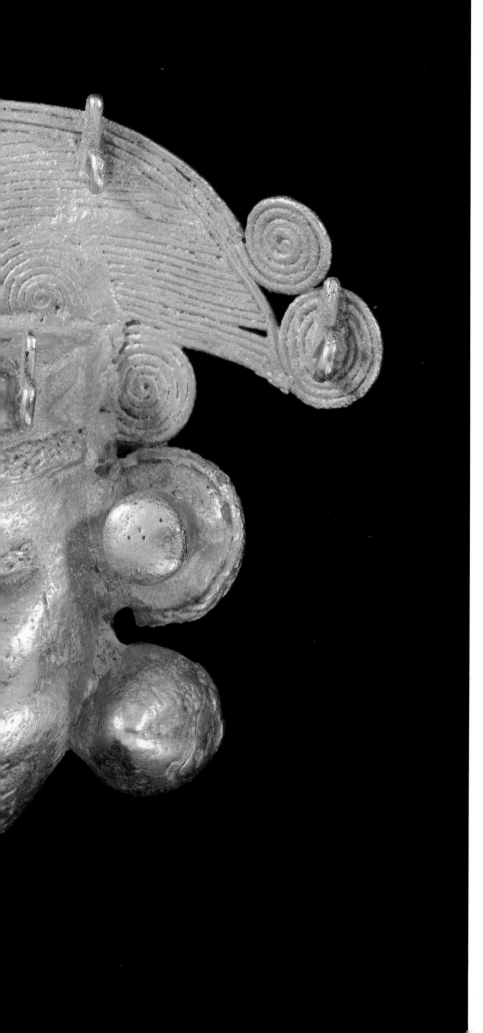

S7. *Pendant in the Form of a Mask,*
Sinú Region.

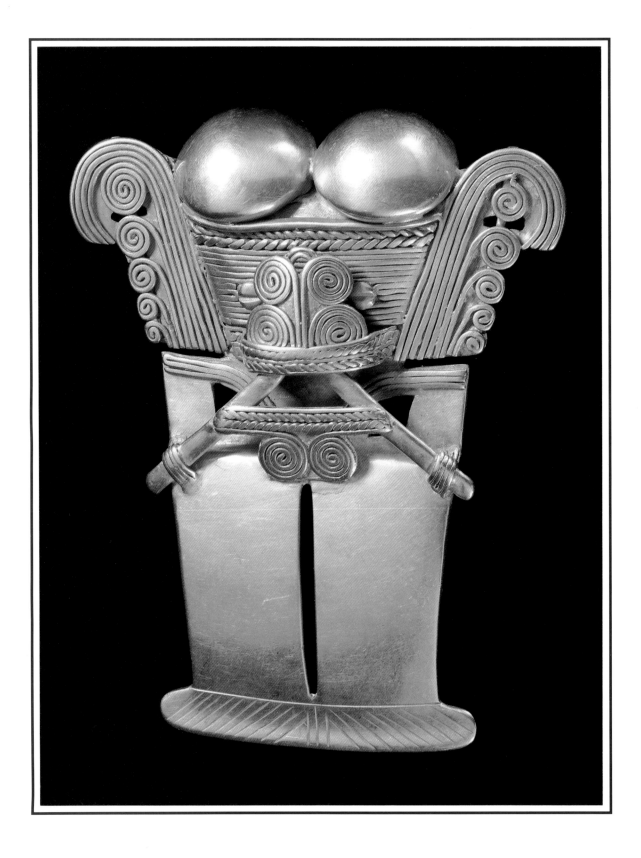

S8. *Highly Abstract Anthropomorphic Pendant,* Sinú Region.

The lands of the great Tairona culture lay far to the north of the Muisca homeland, in what is today the modern Department of Magdalena, east of the Magdalena River and west of the departments of La Guajira and Cesar.

The Sierra Nevada de Santa Marta, an isolated, massive rock formation containing snow-capped peaks, some of which peer over 17,000 feet above sea level, is the most prominent geological and topographical feature of this region. Below the cold, sharp, craggy peaks lie a number of diverse ecological zones. Ranging from rain forests to semi-desert lands, these zones change as one descends from the frigid peaks to the warmer climes of the coast. The amount of annual rainfall in the Sierra Nevada is directly correlated to the cardinal direction of the mountain slope; the north and west slopes are generally wetter than those of the east and south. Tairona culture was centered in the lower elevations, generally below 3,000 feet above sea level.

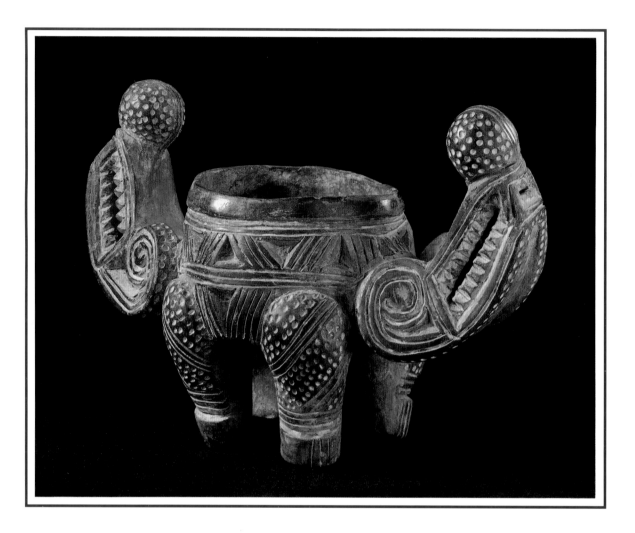

T1. *Double-Headed Zoomorphic Vessel,* Tairona Region.

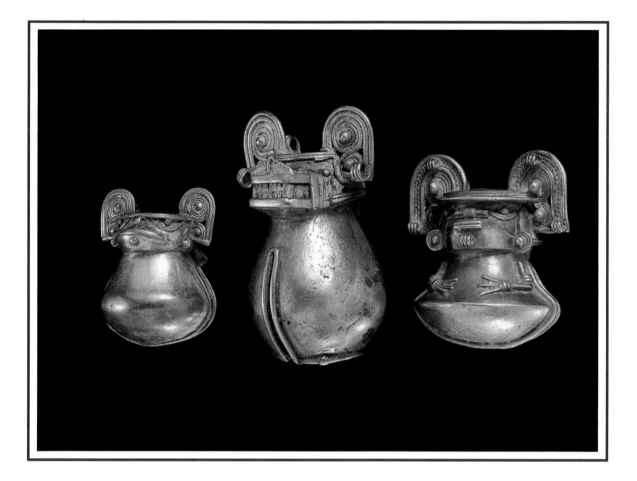

T2. *Anthropomorphic Bells,* Tairona Region.

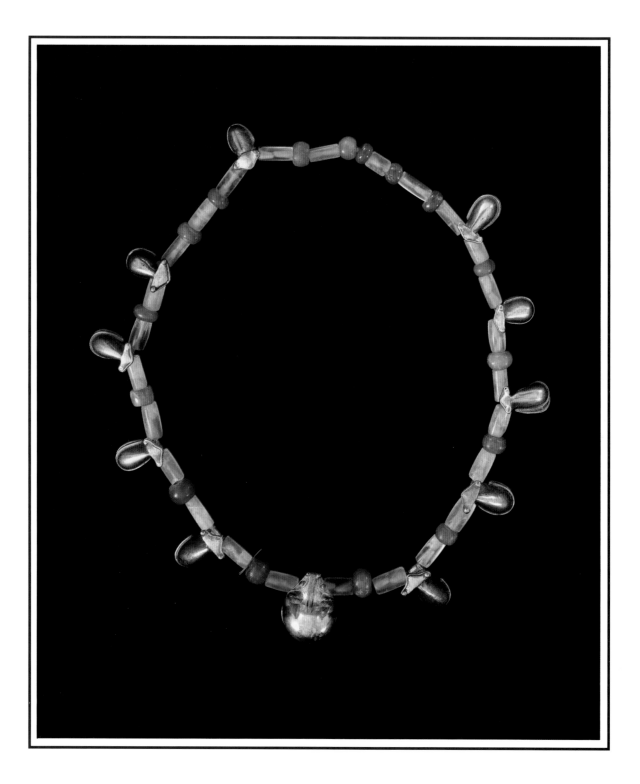

T3. *Necklace with Zoomorphic Pendants,* Tairona Region.

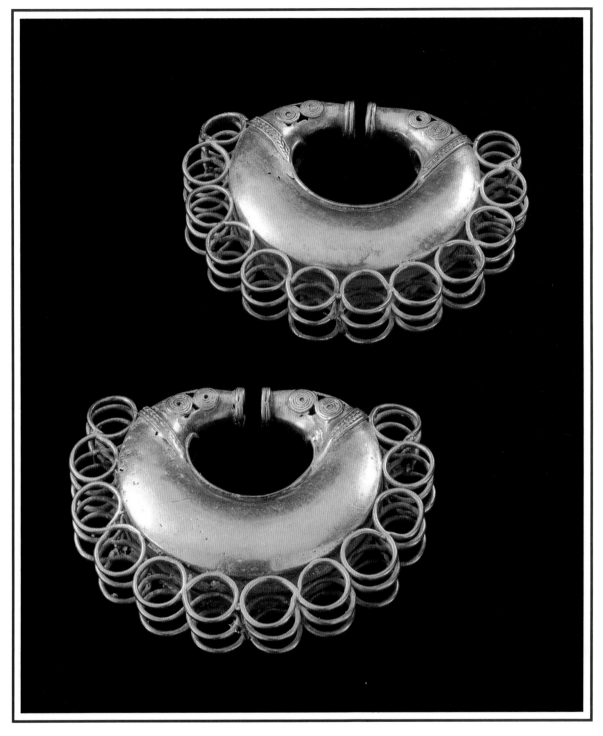

T4. *Pair of Ear Ornaments,* Tairona Region.

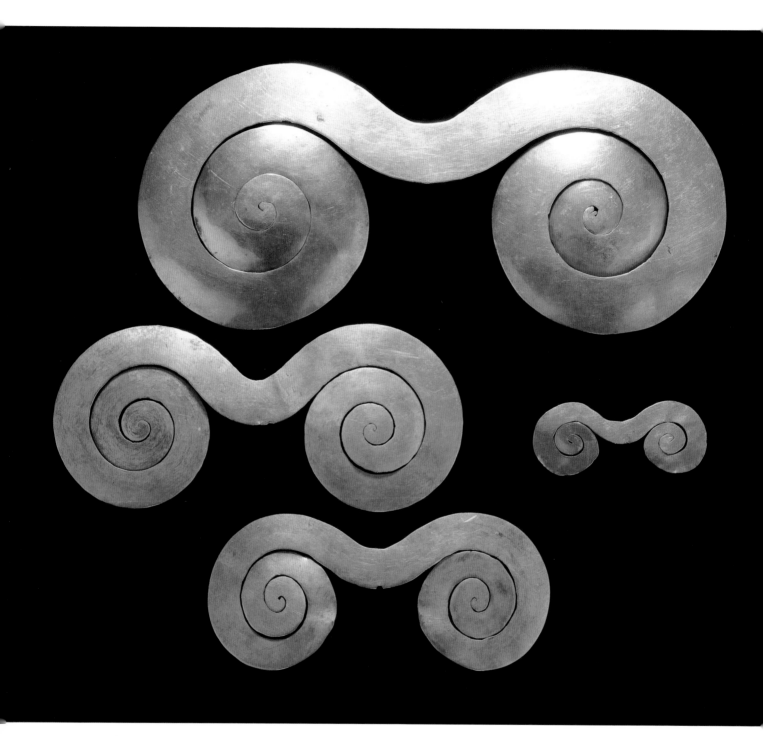

T5. *Group of Double Spiral Ornaments,* Tairona Region.

Far to the northeast of Nariño lay the Muisca homelands, the lands of "El Dorado," nested in the fertile highland basins of Bogotá and Tunja in the modern departments of Cundinamarca and Boyacá. Much of the native vegetation and natural fauna has disappeared, replaced by species introduced since the Spanish Conquest. The contours of the natural topography, however, remain.

Boyacá, noted for its emerald-bearing geologic formations, is crossed by many rivers and dotted with lagoons. Here the Muisca were centered in the valleys of Chiquinquirá, Sogamoso, Tenza, Ramirigui, and the *altiplano* of Tunja.

The Muisca of Cundinamarca inhabited Bacatá, as well as places like Nemocón and Zipaquirá, noted for their salt mines.

Other areas, such as Muzo (within the Panches territory), Somondoco, and Ubala, were important regions of Emerald mining. Muisca lands were also rich in coal and copper, and this mineral wealth was the foundation of their mercantile power.

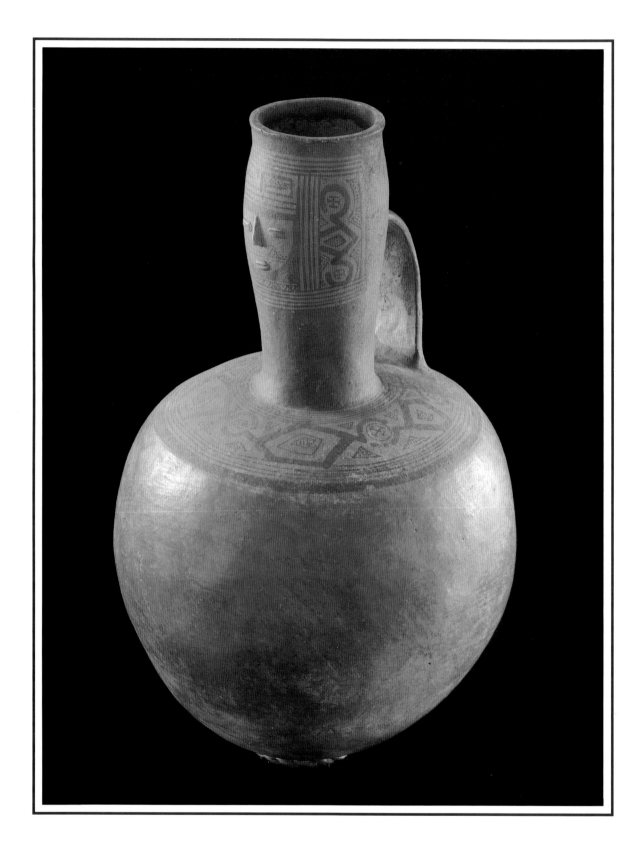

M1. *Globular Long-Necked Jar with Anthropomorphic Face,* Muisca Region.

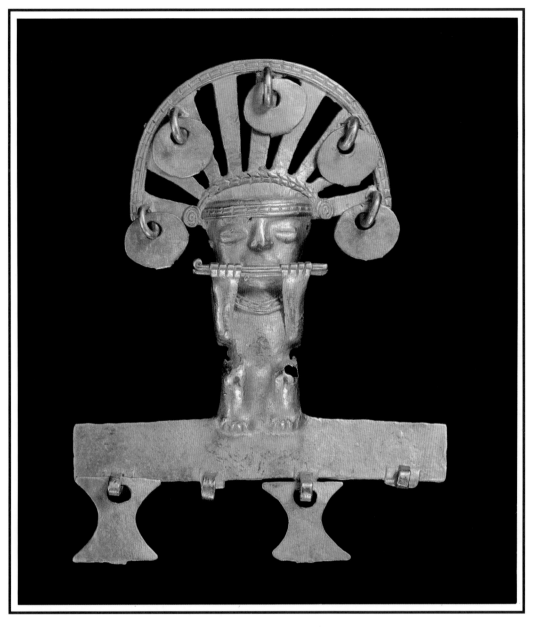

M2. *Pendant in the Form of a Seated Figure,*
Muisca Region.

M3. *Pectoral in the Form of a Standing Figure,* ▶
Muisca Region.

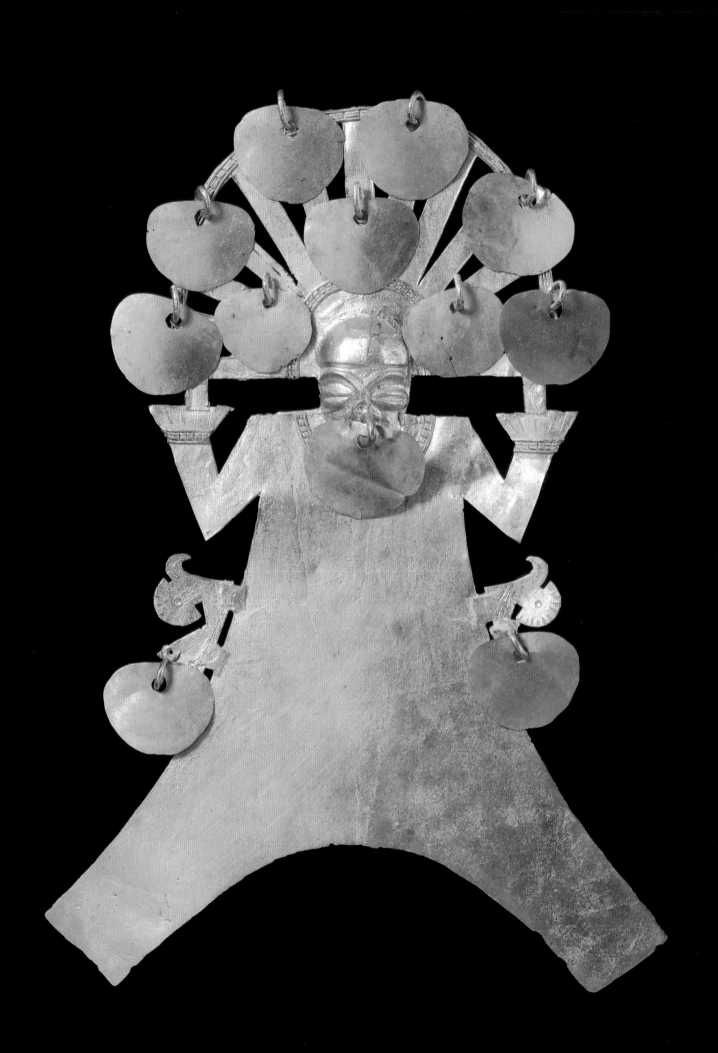

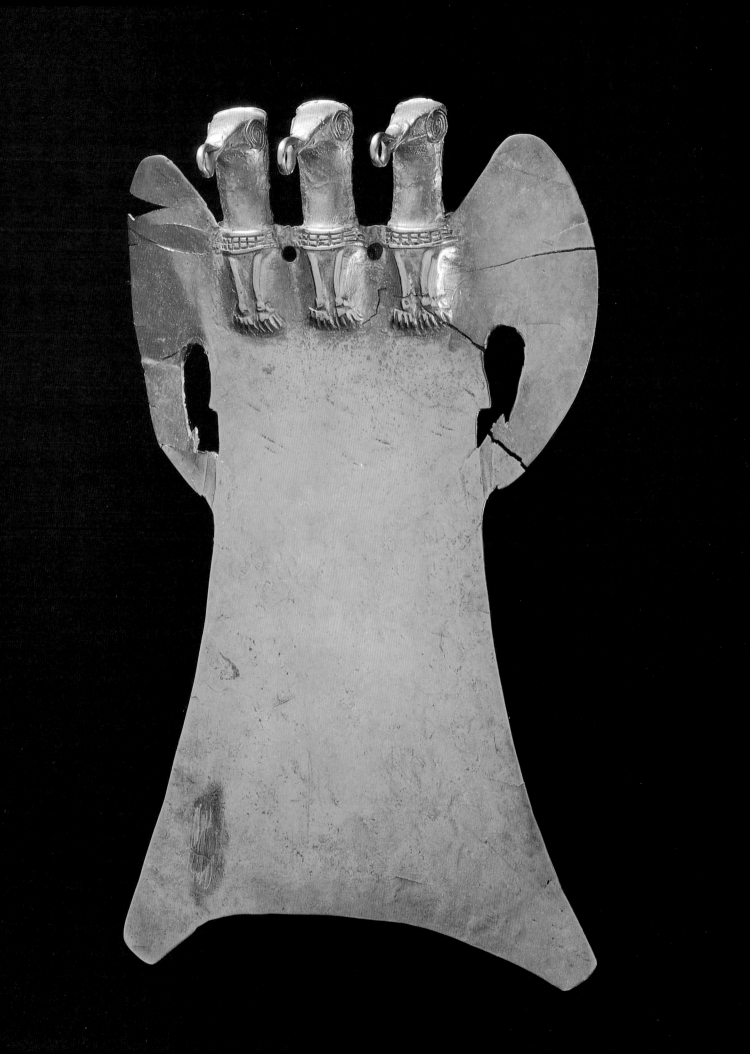

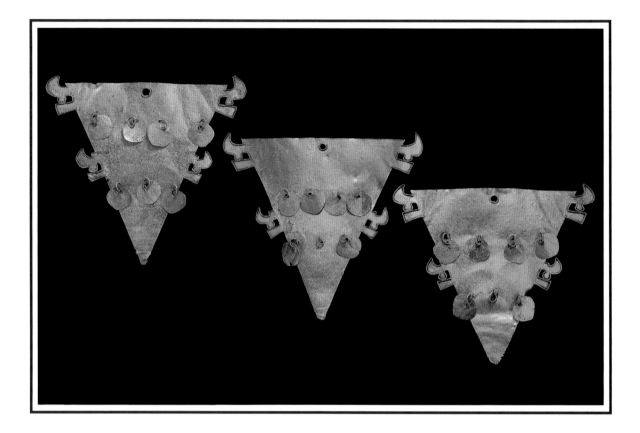

◀ **M4**. *Pectoral in the Form of a Triple-Bodied Bird,*
Muisca Region.

M5. *Triangular Pectoral Ornaments with Danglers,*
Muisca Region.

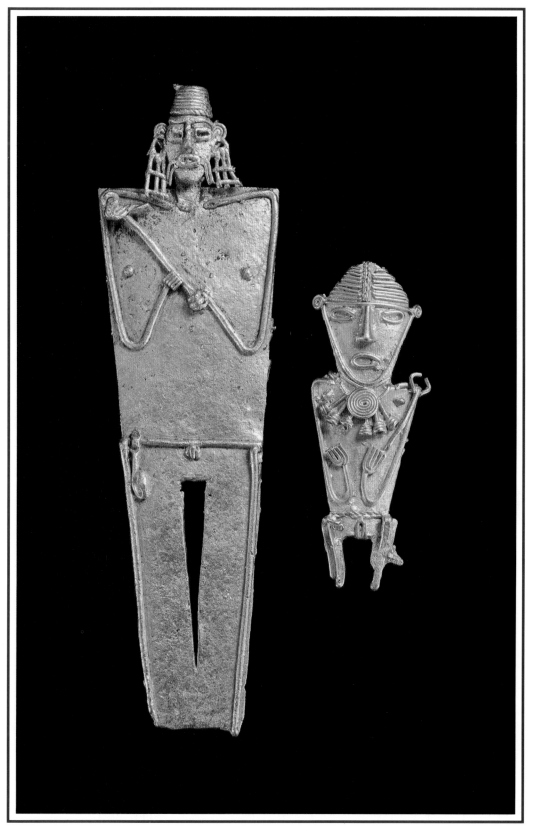

M6. *Anthropomorphic Votive Figures (Tunjos),* Muisca Region.

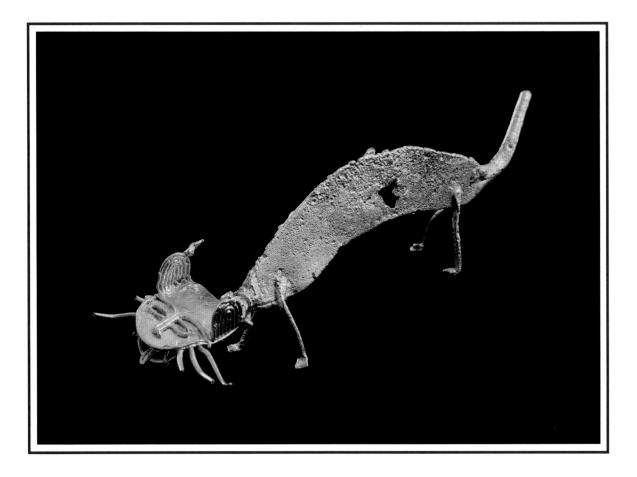

M7. *Votive Figure in the Form of a Feline,* Muisca Region.

The Tolima region lies within the reaches of the middle Magdalena River, which courses through torrid lowlands between the Eastern and Central Cordilleras. The source of the Magdalena is to be found southward in the region of San Agustín. Although important burial sites have been found along the middle Magdalena, particularly in the region of Rio de la Miel and around the Río Palagua, little is known concerning the prehistory of this region or of the Valle del Río Magdalena.

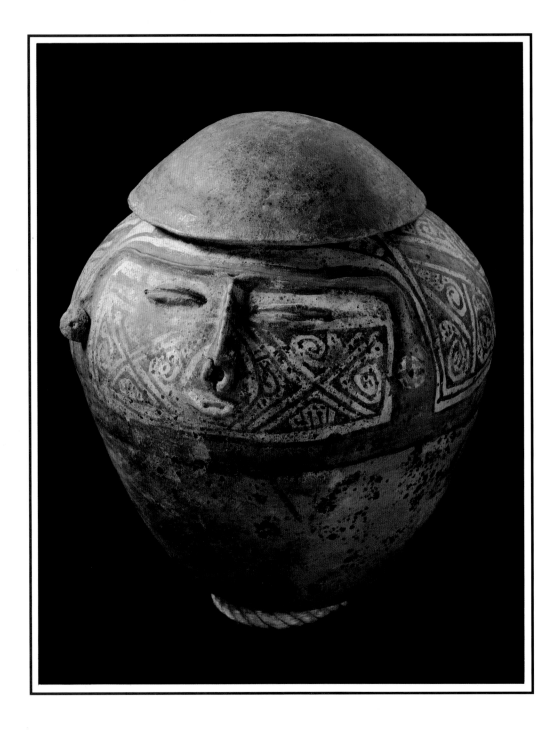

T01. *Anthropomorphic Funerary Urn,* Tolima Region.

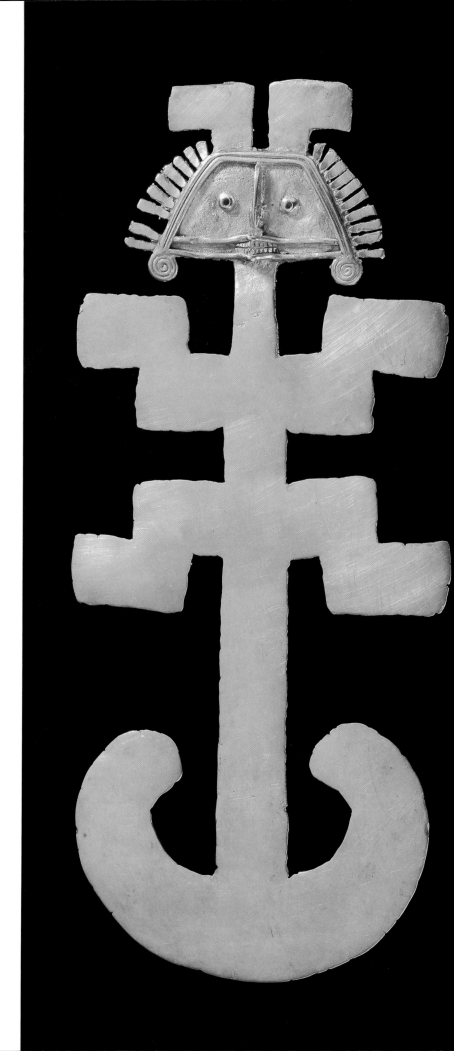

T02. *Pectoral with Human and Animal Characteristics,* Tolima Region.

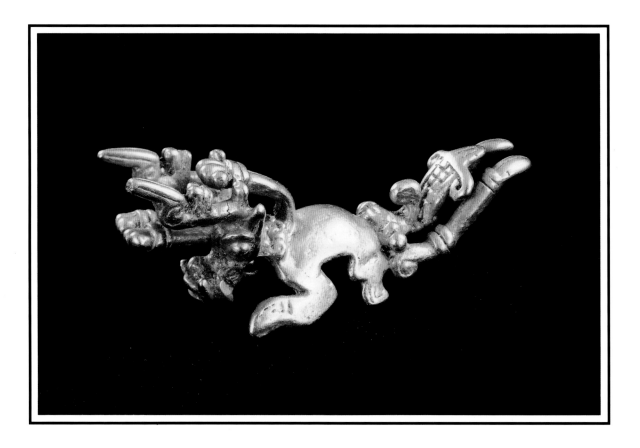

T03. *Pendant in the Form of a Fantastic Being,* Tolima Region.

The Department of Nariño, which lies southwest of San Agustín, is divided into three distinct geographic zones: the Pacific coastal lowlands, the Andean highlands, and the Eastern tropical lowlands.

The Andean highlands of Nariño are separated into a number of subregions: the Tuquerres-Ipiales *altiplano*, a region of high, fertile flat-lands; the central region, composed of a rugged topography with contrasting majestic peaks, flat plains, and picturesque valleys; and the northern region, which blends soft hills with rugged slopes.

The Department of Nariño is the home of many active and inactive volcanos, the most prominent of which are El Galeras, El Cumbal, El Azufral, El Donna Juana, and El Chiles. These volcanoes, in part, are responsible for many of the igneous rocks, such as andesites and basalts, found in the highlands.

Andean Nariño also spawns numerous lagoons and rivers which course toward the Pacific lowlands in the west and the tropical lowlands in the east.

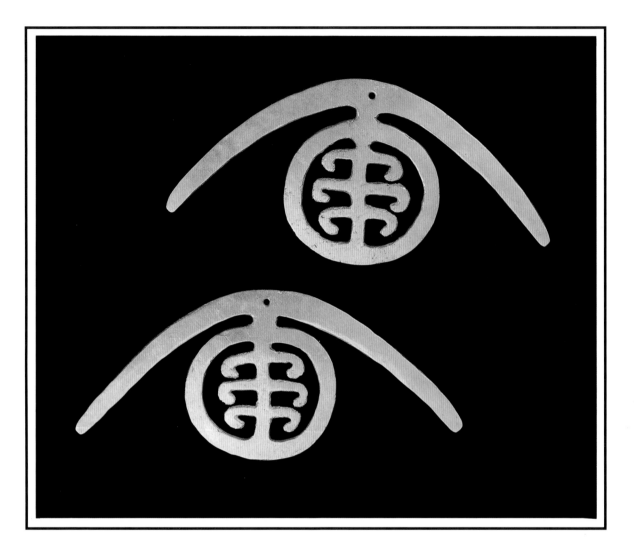

N1. *Pair of Ear Pendants,* Nariño Region.

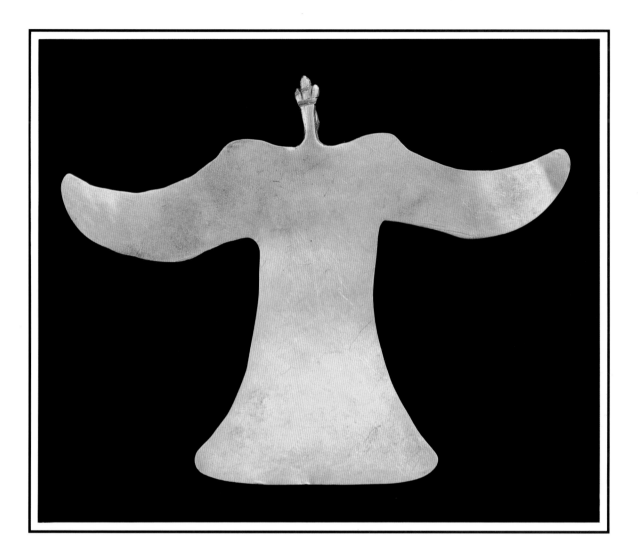

N2. *Bird Form with Outspread Wings,* Nariño Region.

PHOTO TEXT

CALIMA REGION

C1 PAIR OF EAR PENDANTS
6.8 cm. h. x 9.6 cm. w.
Early Calima Style.
Cut and Hammered Gold with Repousee Design
and Danglers.

The center of each pendant is in the form of a
human face. The pendant itself is in a form
reminiscent of a bird with outstretched wings.
Large disc-shaped danglers are attached to the
sides of the face by means of wire staples. Some
researchers (Reichel-Dolmatoff, G.) have
hypothesized that forms such as these are
iconographic representations of shamans in
mystical flight. These pendants are representa-
tive of a motif known as Icon A. According to
this hypothesis, Icon A consists of a shaman in
the form of a bird-man. He is sometimes
accompanied by animal familiars, often in the
form of birds.

Museo del Oro 7516, 7515

C2 HEART-SHAPED PECTORAL
22.3 cm. h. x 28 cm. w.
Early Calima Style.
Cut and Hammered Sheet Gold with Repousee
Designs and Danglers.

The center of the pectoral is in the form of a
human face, decorated with large earspools and
nose danglers, which are attached to the central
figure by means of wire staples. The pectoral,
itself, is in a form reminiscent of stylized
outstretched bird wings. The nose plaque of the
central face incorporates the face of an animal,
possibly a feline. Additionally, the face of a
feline is still distinguishable at the center of the
left disc-shaped dangler. The edge of the wings
is decorated with a band of repousee designs
incorporating geometrics and possibly stylized
bird and zoomorphic elements. Stylistically and
iconographically, this artwork is similar to C1.

Museo del Oro 3331

C3 WING-SHAPED NOSE ORNAMENT WITH
DANGLERS
13.0 cm. h. x 5.7 cm. h.
Early Calima Style.
Cut and Hammered Gold with Danglers
Attached with Wire Staples.

The overall impression of the design is that of a
bird with wings outstretched, although in the
case of this artwork this interpretation must
remain hypothetical. A row of 13 disc-shaped
danglers decorates the central field. A series of
23 elongate danglers decorates the lower field.
Decorative repousee dots are arranged in a band
above the central field and are used profusely on
each elongate dangler. One elongate dangler is
missing, which would have brought the original
total to 24. In many Pre-Columbian cultures
dots were used to symbolize seeds, or the
potential new life brought about by the process
of fertilization. Numerical coefficients were also
often symbolic in nature. With respect to the
Calima region, however, little is known of the
symbolic significance of the iconography seen in
the artwork. For this reason, any interpretation
of the meaning of such iconography must of
necessity remain hypothetical.

Museo del Oro 4319

C4 NECKLACE WITH TWENTY-EIGHT
ZOOMORPHIC PENDANTS
2.3 cm. h. x 1.0 cm. w. each.
Cast Gold.

Each pendant is characterized by a large trap-
ezoidal body and a small head. The form may
represent a highly stylized bird or other
zoomorph.

Museo del Oro 5804

C5 PECTORAL
15.1 cm. h. x 19.7 cm. w.
Early Calima Style.
Cut and Hammered Gold with Repousee
Designs in Relief.

The decoration in relief is dominated by two
pairs of stylized monkeys, depicted as running.
The two lower monkeys are shown facing one
another. Dots are used to decorate the border
and are arranged semi-circularly in groups of five
along the edge of the artwork. Dots are also

used to outline the upper body of each monkey. The artist has imparted a distinct bi-lateralism to the motif, while added emphasis on duality is achieved by grouping the monkeys in pairs and by positioning each pair in an opposing fashion.

Museo del Oro 3682

C6 HUMAN FACE MASK
12.5 cm. h. x 15.9 cm. w.
Early Calima Style.
Sheet gold probably shaped over a wooden template.

Museo del Oro 7475

C7 PECTORAL WITH HUMAN FIGURE IN RELIEF
20.3 cm. h. x 16.0 cm. w.
Early Calima Style.
Cut, Hammered, and Embossed Gold.

The central figure stands in deep contemplation or repose. The pectoral is crescent-shaped at the base and bifurcated above. Although the overall impression is that of outstretched wings, in this example the wings would appear to be those of a butterfly, rather than those of a bird. It is also possible that neither bird wings nor butterfly wings were intended by the artist.

Museo del Oro 416

C8 TWEEZER-SHAPED PENDANT WITH STYLIZED FACE IN RELIEF
20.6 cm. h. x 13.4 cm. w.
Early Calima Style.
Cut and Hammered Gold Folded Double.

This artwork incorporates the heart-shaped bilateralism of the outstretched wing forms seen in other Early Calima gold ornaments, as well as the crescent-shaped outstretched wing form, seen along the base. Stylized triangular eyes, nose, and mouth are skillfully employed by the artist to impart a fierce and penetrating face to the composition.

Museo del Oro 3564

C9 LIME DIPPER INCORPORATING A HUMAN FIGURE
22.6 cm. h. x 2.1 cm. w.
Early Calima Style.
Cast Gold.

The delicacy and complexity of casting is exemplary in this genre. Lime dippers, of which this is a highly ornate example, were used to collect small quantities of lime utilized in the chewing of coca leaf. Typically, a wad of coca leaf was placed in the mouth. The dipper was placed in a small container of lime called a poporo. The lime adhering to the dipper was then placed in the mouth. The lime served to extract the neuroactivating alkaloids from the coca leaves. The shaft of these artworks is round and often pointed at the base.

Museo del Oro 6432

QUIMBAYA REGION

Q1 NOSE ORNAMENT WITH DANGLERS
10.2 cm. h. x 10.2 cm. w.
Quimbaya Region.
Hammered Tumbaga.

The ornament comprises seven danglers. Each dangler has a hole at one end for suspension. The ornament, itself, is suspended from the ear by means of a single, flat, hook.

Museo del Oro 2272

Q2 NOSE ORNAMENT
2.1 cm. h. x 5.3 cm. w.
Quimbaya Region.
Cast Gold.

Museo del Oro 7727

Q3 ZOOMORPH IN THE FORM OF AN ALLIGATOR OR LIZARD
22.5 cm. l. x 5.5 cm. w.
Quimbaya Region.
Hammered Gold.

Museo del Oro 787

Q4 FACE MASKETTE
3.5 cm. h. x 3.2 cm. w.
Quimbaya Region.
Cast Tumbaga.

The artist has deftly captured the sentiments of composure and serenity with minimal delinea-

tion of facial detail. This example is very similar to another maskette in the Museo del Oro's collection from Calarca, Quindio.

Museo del Oro 5975

Q5 HOLLOW STANDING FEMALE AND SEATED MALE FIGURES
Female: 24.0 cm. h. x 11.3 cm. w.
Male: 20.0 cm. h. x 19.0 cm. w.
Quimbaya Region.
Red-Slipped Ceramic Sculptures.

Museo del Oro 12802, 12801

SINÚ REGION

S1 RING-BASED STEMMED CUP WITH LID
25.6 cm. h.
Sinú Region.
Ceramic.

The stem of the vessel is in the form of an anthropomorphic figure. The knob of the lid is in the form of a long-tailed zoomorph with a human-like face. Fine-line incising complements the elegant execution of this artwork.

Museo del Oro 4187

S2 STAFF FINIAL IN THE FORM OF A BIRD
4.7 cm. h. x 7.2 cm. l.
Sinú Region.
Cast Tumbaga.

The bird is depicted in a seated or standing position with its wings tucked in. Two crests adorn the top of the head. Spiral plaques can be seen on the breast and neck. The back of the tail end of the bird has been modified so that the finial can be attached and secured to the end of a baton or staff.

Museo del Oro 29226

S3 ZOOMORPHIC PENDANT
3.7 cm. h. x 3.3 cm. l.
Sinú Region.
Cast Gold.

The front paws of the animal have been shaped into loops used to suspend the figure. The face of the figure has been given almost human-like features.

Museo del Oro 17636

S4 ZOOMORPHIC PENDANT
5.3 cm. l. x 3.3 cm. w.
Sinú Region.
Cast Gold.

The loops adjacent to the front paws of the animal serve to suspend the artwork from a necklace. The body of the animal is almost formless. The artist has chosen to accentuate the front and hind portions of the figure.

Museo del Oro 6930

S5 ABSTRACT ZOOMORPHIC STAFF FINIAL
8.2 cm. h. x 5.9 cm. w.
Sinú Region.
Cast Gold.

Museo del Oro 32507

S6 PAIR OF EARRINGS WITH DISC PENDANTS
6.1 cm. d. and 6.0 cm. d. of largest discs.
Sinú Region.
Hammered Gold.

Museo del Oro 33123, 33124

S7 PENDANT IN THE FORM OF A MASK
7.0 cm. h. x 9.6 cm. w.
Sinú Region.
Cast Gold.

The headdress is embellished with multiple spirals. A nose plaque has been attached to the nose sceptum of the mask.

Museo del Oro 6403

S8 HIGHLY ABSTRACT ANTHROPOMORPHIC PENDANT
11.6 cm. h. x 9.5 cm. w.
Darien Style. Sinú Region.
Cast Gold.

This figure is in a style known as Darien. Darien pendants or pectorals are a genre found over

wide areas of Colombia, stretching from the Tolima region to the Sinú region and along the Caribbean coast. The central figure in this example is rendered in a highly abstract manner. Very little of the human form is discernible. In many Darien pectorals the central figure's head, arms, and legs are clearly visible. Typically, the figure holds two baton-like implements, one in each hand. These are held inward toward one another. Mushroom-like knobs are more often than not placed atop the head. The figure may represent a masked shaman, priest, or officiate in ritual garb.

Museo del Oro 6419

TAIRONA REGION

T1 DOUBLE-HEADED ZOOMORPHIC VESSEL
9.5 cm. h. x 14.5 cm. l.
Santa Marta, Magdalena. Tairona Region.
c. 1000 - 1600 A.D.
Ceramic.

The vessel is in the form of a double-headed fantastic creature. The legs of the zoomorph serve as the supports of the vessel. The ears of the animal are formed of spiral elements. The body is decorated with dots and paired and opposing triangular elements. Parallel bands are arranged in the form of a repeating band of chevron-shaped elements. Within the context of a widely used geometric symbol tradition the dots would represent seeds or fertility. The repeating chevron element represents water, while the spiral represents wind, air, or motion. The emphasis on duality as depicted by the two heads would be an allusion to the inherent duality of nature and phenomena. Unfortunately, we do not know if the Tairona used these geometric forms in the same manner as other groups for which we have good ethnographic data on their symbolic content.

Museo del Oro 977

T2 ANTHROPOMORPHIC BELLS
Left: 2.7 cm. h. x 2.3 w.
Middle: 3.4 cm. h. x 2.3 cm. w.
Right: 4.4 cm. h. x 3.0 cm. w.
Tairona Region.
Cast Tumbaga.
The bell serves as the body of the figure. Each figure wears a headdress, characterized by spiral ornaments. The arms of the figure on the right are indicated schematically in relief. The figure in the middle is wearing a zoomorphic mask.

Museo del Oro 12835, 29730, 14855

T3 NECKLACE WITH ZOOMORPHIC PENDANTS
2.4 cm. l. x 2.5 cm. w. (each pendant)
Tairona Region.
Quartz and Carnelian Beads with Cast Tumbaga Pendants.

The smaller pendants are cleverly cast as dual animals depending on how they are positioned. When viewed from one perspective they are in the form of seated frogs. When turned over and viewed from the opposite perspective, they represent pelicans. The pelican is common to the coastal regions of the Sierra Nevada de Santa Marta, the former Tairona heartland.

Museo del Oro 32056

T4 PAIR OF EAR ORNAMENTS
Upper: 6.2 cm. h. x 8.1 cm. w.
Lower: 6.4 cm. h. x 8.3 cm. w.
Tairona Region.
Cast Alloy, Depletion Gilded.

Each ornament is embellished with six pairs of interlocking circles, arranged in rows of three. Each pair of circles is formed from a continuous fillet, arranged in the shape of a figure eight. The spiral plaques at the ends of each ear ornament repeat this pattern as they are also formed from a continuous fillet. This pattern has unmistakable dualistic significance. A double spiral pattern in some cultures connotes the process of emergence, manifestation, and eventual dissolution and absorption, such as birth, growth, decay, and death among plants and animals. We have no solid ethnographic documentation for this interpretation, however, for the Tairona.

Museo del Oro 13554, 13555

T5 GROUP OF DOUBLE SPIRAL ORNAMENTS
Upper: 18.9 cm. w. x 8.4 cm. h.(Tumbaga)
Middle Left: 13.1 cm. w. x 5.7 cm. h (Tumbaga).
Middle Right: 5.5 cm. w. x 2.2 cm. h. (Gold)
Lower: 10.9 cm. w. x 4.9 cm. h. (Gold)
Tairona Region.
Cut and Hammered Gold and Tumbaga.

Ornaments such as these undoubtedly had powerful symbolic significance. Although ethnographic support for a specific interpretation of these double spiral motifs is lacking for the Tairona, the concepts of dualism and continuity are inherent in the form. In other cultures, double spirals sometimes connote the process of birth-growth-decay-death in plants and animals and emergence-manifestation-dissolution-absorption for phenomena in general.

Museo del Oro 11639, 15827, 17457, 16897

MUISCA REGION

M1 GLOBULAR LONG-NECKED JAR WITH ANTHROPOMORPHIC FACE
36.6 cm. h. x 24.0 cm. w.
Muisca Region.
c. 1400 - 1540 A.D.
Slipped, Burnished, and Painted Ceramic.

A sensitively executed, elegant example of this genre. Thin fillets of clay have been sparingly applied to the neck of the vessel to form the eyes, nose, and mouth of an anthropomorphic face. Jars such as this are called "mucura." They were used to hold and serve liquids.

Museo del Oro 12765

M2 PENDANT IN THE FORM OF A SEATED FIGURE
10.0 cm. h. x 7.5 cm. w.
Muisca Region.
c. 1000 - 1540 A.D.
Cast Tumbaga.

Circular danglers decorate the figure's headdress. Hour-glass shaped danglers hang from the rectangular base.

Museo del Oro 7800

M3 PECTORAL IN THE FORM OF A STANDING FIGURE
15.9 cm. h. x 11.8 cm. w.
Muisca Region.
c. 1000 - 1540 A.D.
Cast Gold.

Circular danglers are attached to the figure's headdress, as well as to the tail of the small bird figures seen flanking the central figure. An additional dangler serves as the figure's nose plaque. Some of the danglers appear to be gold rich tumbaga, an alloy of gold and copper.

Museo del Oro 7550

M4 PECTORAL IN THE FORM OF A TRIPLE-BODIED BIRD
14.7 cm. h. x 9.1 cm. w.
Muisca Region.
Cast Gold.

The bird has three heads and three pairs of legs, but one body and set of wings. The eyes are in the form of spiral plaques.

Museo del Oro 6737

M5 TRIANGULAR PECTORAL ORNAMENTS WITH DANGLERS
Left: 15.4 cm. h. x 17.7 cm. w.
Middle: 15.3 cm. h. x 17.4 cm. w.
Right: 14.7 cm. h. x 17.4 cm. w.
Muisca Region.
Cast Gold.

Museo del Oro 7239, 7240, 7237

M6 ANTHROPOMORPHIC VOTIVE FIGURES (TUNJOS)
Left: 12.4 cm. h x 3.6 cm. w.
Right: 6.3 cm. h. x 2.2 cm. w.
Muisca Region.
Cast Gold.

Figures such as these were cast to be used as votive offerings. They were sometimes deposited in small bowls. Typically, the arms and legs and other details are indicated by means of thin fillets. The larger standing figure holds an adze-shaped implement in his hands. The smaller seated figure wears a necklace containing a large spiral plaque as a center piece.

Museo del Oro 6913, 11245

M7 VOTIVE FIGURE IN THE FORM OF
A FELINE
8.2 cm. l.
Muisca Region.
Cast Gold.

The feline seems to be chewing a large spider as
there appear to be eight fillets (legs) extending
from the feline's mouth. The thin slab-like
formation of the feline's body and the thin fillets
forming the legs give the appearance of emacia-
tion.

Museo del Oro 32884

TOLIMA REGION

T01 ANTHROPOMORPHIC FUNERARY URN
23.5 cm. l.
Espinal, Tolima Region.
Painted Ceramic.

Thin fillets of clay are used to form the eyes,
nose, and mouth of a human face. A metal
nose-ring is indicated in clay. Jars such as this
were used to place the bones of the deceased.

Museo del Oro CTO 936

T02 PECTORAL WITH HUMAN AND ANIMAL
CHARACTERISTICS
36.5 cm. h. x 15.5 cm. w.
Tolima Region.
Cast Gold with Post Cast Hammering.

The figure combines human and animal
characteristics. Duality is powerfully emphasized
by the oppositional placement of the upward
raised arms and the emphatic downward thrust
and placement of the legs and feet. Opposi-
tional duality is also emphasized by the rectilin-
ear outward pointing rectangular elements atop
the head as opposed to the curvilinear inward
pointing crescent tail.

Museo del Oro 5834

T03 PENDANT IN THE FORM OF A FANTAS-
TIC BEING
5.5 cm. l. x 1.4 cm. w.
Tolima Region.
Cast Gold.

The figure has the legs of a man, the body of an
animal, and two zoomorphic heads. The form
and position is reminiscent of ethnographic tales
of shape-shifting shamans in mystical flight.

Museo del Oro 5870

NARIÑO REGION

N1 PAIR OF EAR PENDANTS
Upper: 5.1 cm. h. x 11.8 cm. w.
Lower: 5.4 cm. h. x 11.6 cm. w.
Nariño Region.
Cast Gold with Post Cast Hammering.

Museo del Oro 24683, 24684

N2 BIRD FORM WITH OUTSPREAD WINGS
9 cm. w.
Nariño Region.
Hammered Gold.

Museo del Oro 22451

BIBLIOGRAPHY

Archila, Sonia
Investigación Arquelógica en el Noroccidente de Boyacá.
Graduation Dissertation (Unpublished). Universidad
de los Andes, Bogotá, 1985.

Ardila, Gerardo
"Alto de Mira, Dos Fechas de C.14 del Alto Río
Buritaca." *Boletín de Arqueología*, Year 1, No. 4.
Fundación de Invetigaciones Arquelógicas Nacionales,
Banco de la República, Bogotá, 1986.

Banco de la República
Minutes from the Board of Governors, Nos. 505 and
1174 from March and May 1939.

Banco de la República. Fundación de investigaciones
arqueológicas nacionales. *Informe de labores 1972—
1984 y Manual para la presentación de proyectos,*
Bogotá, Colombia, 1985.

Barney Cabrera, Eugenio
"Arte monumental e ilustración gráfica." *Historia del
Arte Colombiano.* Vol. 6, Barcelona, 1977. Cited by
Londoño Valdez, Santiago.

Bergse, Paul
"The Metallurgy and Technology of Gold and
Platinum among the Pre-Columbian Indians." Gad,
F.C. Reynolds, Translator. Inverniorvidensekabelige
Skrifter, A44, Copenhagen: Naturvidenskabelige
Samfund i Kommision hos G.E.C., 1937.

Bischof, Henning
"Contribuciones a la cronología de la Cultura Tairona
(Sierra Nevada de Santa Marta, Colombia)."
*Verhandlungen des XXXVIII Internationalen-
Amerikanischen Kongresses*, Band 1:259—269,
Stuttgart-München, 1969.

Bischof, Henning
"La Cultura Tairona en el Area Intermedia."
*Verhandlungen des XXXVI Internationalen
Amerikanischen Kongresses*, Band 1:272—280,
Stuttgart-München, 1969-b.

Bouchard, Jean François
"Hilos de oro martillado hallados en la Costa Pacífica
del sur de Colombia." *Boletín Museo del Oro*, Banco de
la República, Year 2, May-August, 21-24. Bogotá,
1979.

Bouchard, Jean François
*Reserches archéologiques dans la région de Tumaco,
Colombie.* Institute Francais d'Etudes Andines 34.
Paris, 1984.

Bray, Warwick
The Prehispanic Metalwork of Central Panama. Manu-
script to be published by Editorial Universitaria,
Panama.

Bray, Warwick, Leonor Herrera and Marianne
Cardale de Schrimpff
Pro-Calima Magazine, Nos. 1, 2, 3 and 4.
Vereinigung, Basel, Switzerland.

Bruhns, Karen
"Stylistic Affinities Between the Quimbaya Goldstyle
and a Little-Known Ceramic Style in the Middle
Cauca Valle, Colombia." *Ñawpa-Pacha*, 7-9. 1970.

Bruhns, Karen
"Ancient Pottery of Middle Cauca Valley, Colombia."
Cespedesia. Vol. 5, Nos. 17-18: 101-196. Cali, 1976.

Cadavid, Gilberto and Luisa Fernanda Herrera de
Turbay
"Manifestaciones culturales en el área Tairona."
Informes Antropológicos, No. 1. Instituto Colombiano
de Antropología, Bogotá.

Cardale de Shrimpff, Marianne
La Colina de la sal, Zipaquirá. Patrones de
asentamiento durante la época Pre-Colombina y la
Colonia (unpublished). Fundación de Investigaciones
Arqueológicas Nacionales, Banco de la República,
Bogotá, 1982.

Castaño, Carlos
"Reporte de un yacimiento arqueológico 'Quimbaya
Clásico' en el valle del Magdalena: Contribución al
conocimiento de un contexto regional." *Boletín
Museo del Oro*, Banco de la República, No. 20: 3-11.
Bogotá, 1988.

Castillo, Neila
Arqueología de Tunja. Fundación de Investigaciones
Arqueológicas Nacionales, Banco de la República,
Bogotá, 1984.

Castillo Neila
"Complejos arqueológicos y grupos étnicos del siglo
XVI en el occidente de Antioquía." *Boletín Museo del
Oro*, Banco de la República, No. 20: 16-34, Bogotá.

Cooke, Richard, and Warwick Bray
"The Goldwork of Panamá: An Iconographic and
Chronological perspective." *The Art of Pre-Columbian
Gold*, The Jan Mitchell Collection, 1985.

Cortés Alonso, Vicenta
"Visita a los santuarios indígenas de Boyacá." *Revista Colombiana de Antropología,* Vol. IX: 199-273. Bogotá, 1960.

Chaves, Alvaro, y Mauricio Puerta
Excavaciones Arqueológicas en Tierradentro. Fundación de Investigaciones Arqueológicas Nacionales, Banco de la República, (unpublished), Bogotá, 1973-79.

Chaves, Alvaro, y Mauricio Puerta
Entierros Primarios de Tierradentro. Fundación de Investigaciones Arqueológicas Nacionales, Banco de la República, Bogotá, 1980.

Cubillos, Julio César
"Arqueología de Ríoblanco (Chaparral, Tolima)." *Boletín de Arqueología,* Vol. 1:519-591. Bogotá, 1954.

Duque Gómez, Luis
Exploraciones Arqueológicas en San Agustín. Imprenta Nacional, Bogotá, 1964.

Duque Gómez, Luis
Los Quimbayas. Instituto Colombiano de Antropología, Bogotá, 1970.

Duque Gómez, Luis, and Julio César Cubillos
Arqueología de San Agustín. Alto de los Idolos, Montículos y Tumbas. Fundación de Investigaciones Arqueológicas Nacionales, Banco de la República, Bogotá, 1979.

Falchetti, Ana María
The Goldwork of the Sinú Region, Northern Colombia. Mphil Dissertation, University of London, Institute of Anthropology (unpublished), 1976.

Falchetti, Ana María
"Desarrollo de la Orfebrería Tairona en la Provincia Metalúrgica del Norte Colombiano," *Boletín Museo del Oro* No. 19, Bogotá, 1987.

Forero, Santos
Cited by Pérez de Barradas, José. *Orfebrería prehispánica de Colombia,* Quimbayan styles and others, p. 335. Madrid, 1966

Groot de Mahecha, Ana María
"Buritaca 200: una fecha de radiocarbono asociada con objetos de orfebrería Tairona." *Boletín Museo del Oro,* Banco de la República, Year 3, May - August, Bogotá.

Grossman, Joel
"An Ancient Goldworker's Tool Kit. *Archaeology.* Vol. 25, No. 4, 1972.

Labbé, Armand J.
Colombia Before Columbus. Rizzoli International, New York, 1986.

Labbé, Armand J.
Colombia Antes De Colón. Carlos Valencia Editores, Bogotá, 1988.

La ilustración española y americana. No. XXXIV, Sept. 15, p. 158 and No. XLV, Dec. 8, p. 404. Madrid, 1892.

Legast, Anne
La Fauna Mítica Tairona. Fundación de Investigaciones Arqueológicas Nacionales, Banco de la República, Bogotá, 1987.

Londoño Velez, Santiago
Museo del Oro - 50 años. Banco de la República, Bogotá, 1990.

Londoño Valdez, Santiago, cited.

Londoño Vélez, Santiago, cited.

Long, Stanley
Hormas de Piedra y su Uso en la Metalurgia Chibcha. (unpublished). Archivo Museo del Oro, Bogotá, 1967.

Helms, Mary
Ancient Panamá: Chiefs in Search of Power. Austin and London: University of Texas Press. 1979, p. 79, citing Anderson, p.177, 1914.

Oyuela, Augusto
Las Fases Arqueológicas de las Ensenadas de Nahanje y Cinto. Graduation dissertation (unpublished), Universidad de los Andes, Bogotá, 1985.

Pérez de Barradas, José
Orfebrería Prehispánica de Colombia: Estilo Calima. Banco de la República, Bogotá, 1954.

Pérez de Barradas, José
Orfebrería Prehispánica de Colombia: Estilos Tolima y Muísca. Banco de la República, Bogotá, 1958.

Pérez de Barradas, José
Orfebrería Prehispánica de Colombia: Estilos Quimbaya y otros. Banco de la República, Bogotá, 1966.

Pérez de Barradas, José
Orfebrería prehispánica de Colombia. Quimbayan styles and others. Madrid, p. 335, 1966.

Plazas, Clemencia
Catálogo de piezas precolombinas colombianas en 33 museos europeos. Archives Museo del Oro, Bogotá,1972-73.

Plazas, Clemencia
Nueva Metodología para la clasificación de Orfebrería Prehispánica. Jorge Plazas, Bogotá, 1975.

Plazas, Clemencia
"Orfebrería Prehispánica del Altiplano Nariñense, Colombia." *Revista Colombiana de Antropología,* Vol. XXI: 197-244. Instituto Colombiano de Antropología, Bogotá, 1977-78.

Plazas, Clemencia
"Tesoro de los Quimbaya y piezas de orfebrería relacionada." *Boletín Museo del Oro,* Banco de la República, Year 1: May-August. Bogotá, 1978.

Plazas, Clemencia
"Forma y función en el oro Tairona." *Boletín Museo del Oro,* Banco de la República, No. 19. Bogotá, 1987.

Plazas, Clemencia, and Ana María Falchetti
Asentamientos Prehispánicos en el Bajo Río San Jorge. Fundación de Investigaciones Arqueológicas Nacionales, Banco de la República, Bogotá, 1981.

Plazas, Clemencia and Ana María Falchetti
"Tradición Metalúrgica del Suroccidente Colombiano." *Boletín Museo del Oro,* Banco de la República, No. 14. Bogotá, 1983.

Plazas, Clemencia and Ana María Falchetti
Patrones Culturales en la Orfebrería Prehispánica de Colombia. 45° Congreso Nacional de Americanistas, Bogotá, 1985.

Plazas, Clemencia, Ana María Falchetti, Thomas van der Hamme, Pedro Botero
"Cambios Ambientales y Desarrollo Cultural en el Bajo Río San Jorge." *Boletín Museo del Oro,* Banco de la República, No. 20. Bogotá, 1988.

Reichel-Dolmatoff, Gerardo, and Alicia Dussán de Reichel-Dolmatoff
Reconocimiento arqueológico en la hoya del río Sinú. Revista Colombiana de Antropología, Vol. VI, Bogotá, 1958.

Reichel-Dolmatoff, Gerardo
"Investigaciones Arqueológicas en la Sierra Nevada de Santa Marta." Parts 1 and 2. *Revista Colombiana de Antropología,* Vol. II:147-206. Bogotá, 1954.

Reichel-Dolmatoff, Gerardo
Contribuciones al conocimiento de la estratigrafía cerámica de San Agustín, Colombia. Biblioteca del Banco Popular, Bogotá, 1975.

Reichel-Dolmatoff, Gerardo
"Things of Beauty Replete with Meaning. Metals and Crystals in Colombian Indian Cosmology." *Sweat of the Sun, Tears of the Moon: Gold and Emerald Treasures of Colombia.* Natural History Museum of Los Angeles County, Los Angeles, 1981.

Reichel-Dolmatoff, Gerardo
Goldwork and Shamanism. Editorial Colina, Medellín. Colombia, 1988.

Scott, David, and Warwick Bray
"Ancient Platinum Technology in South America." *Platinum Metals Review,* 24:147-157.

Tayler, Donald B.
The Ika and their System of Beliefs. Ph.D. dissertation (unpublished), Oxford University, 1974.

Uribe, María Alicia
"Introducción a la Orfebrería de San Pedro de Urabá, una región del Noroccidente Colombiano." *Boletín Museo del Oro,* No. 20. Bogotá, 1988.

Uribe, María Victoria
"Asentamientos prehispánicos en el Altiplano de Ipiales, Colombia." *Revista Colombiana de Antropología,* Vol. XXI. Bogotá, 1977-78.

Uribe, María Victoria and Roberto Lleras
"Excavaciones en los cementerios Proto-Pasto y Miraflores, Nariño." *Revista Colombiana de Antropología,* Vol. XXIV. Bogotá, 1982-83.

Uricoechea, Ezequiel
Antigüedades neogranadinas. F. Schneider, Berlin, 1854.